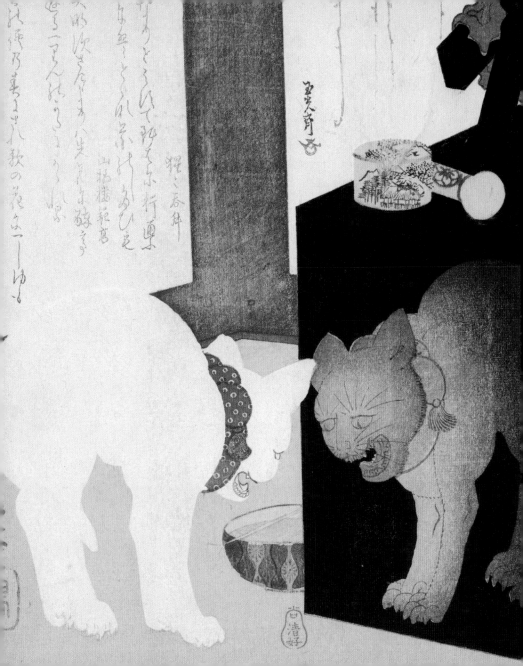

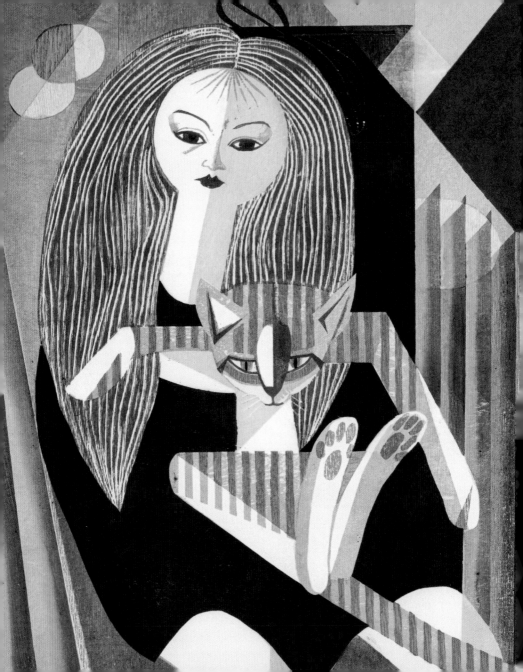

Divine
Felines

The Cat in Japanese Art

RHIANNON PAGET

TUTTLE Publishing

Tokyo | Rutland, Vermont | Singapore

A Brief History of Cats in Japan and Japanese Art

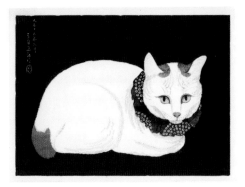

Japan is the undisputed epicenter of global cat culture. One of its most famous exports is the fictional character Hello Kitty, who takes the form of a white cat with a red bow and a blank expression. Conceived by designer Shimizu Yūko (b. 1946) in 1974 for Sanrio corporation, Kitty has been affixed to a bewildering array of products, from vacuum cleaners to regional cuisine to condoms. Riding out the peaks and troughs of postwar economic growth and diversification, Kitty emerged as a global ambassador of *kawaii* (cute) culture, projecting a gentle and humane image of Japan. She continues to reign supreme in this capacity today.

In a land of tiny apartments and long working hours, only the privileged few have the space or lifestyle to accommodate a cat. A few charismatic felines have gained local followings before becoming international celebrities. Unsurpassed among these is Maru (b. 2007), a placid Scottish fold. Hundreds of millions of people around the world have watched mesmerized as Maru squeezed himself into a box slightly too small for his rotund frame with

patient determination, or skidded across the floor into an empty cardboard beer carton. At the time of writing, Maru is the most viewed animal on YouTube.

Maru's comrades include the late Shiro (2002–2020), a white and orange cat in rural Iwate prefecture who rose to fame on Instagram through photos and videos of him napping in baskets and dozing with flowers, farm produce, and the occasional frog balanced on his head. One video from 2015 shows Shiro completely unfazed as a garden snail perches his paw while his friend Kuro tries to sniff and lick it. Shiro is succeeded by his pride of similarly chilled out farm cats, including Mofumofu ("Fluffy") and Chibi ("Shorty"), who regularly appear on Instagram.

For those who crave proximity or interaction with a real flesh-and-fur feline, cat cafes allow customers to enjoy a beverage and/or snack in the presence of these hallowed creatures. Cat cafes originated in Taiwan in 1998, where they were popular with Japanese tourists. The concept was imported to Osaka in 2004, before mushrooming in other urban centers. Cat islands have become hot spots for domestic

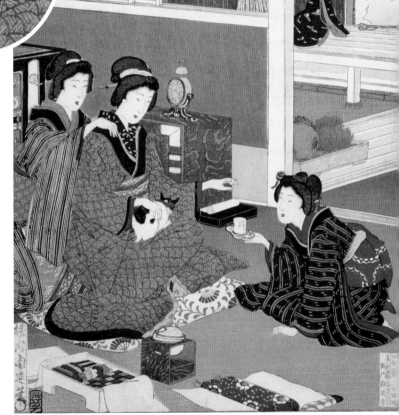

ABOVE AND RIGHT **Yōshū Chikanobu, 1838–1912.** *Prosperity, from the series An Array of Auspicious Customs of Eastern Japan, 1890. Published by Takekawa Unokichi. Woodblock print, ink and color on paper, approx. 15⅜ x 10⅝ in (39 x 27 cm). National Diet Library, Tokyo.*

OPPOSITE **Takahashi Hiroaki (Shōtei) 1871–1945.** *Tama the Cat, 1924. Published by Watanabe Shōzaburō. Woodblock print, ink and color on paper, 10¼ x 13¹⁵⁄₁₆ in (26 x 35.5 cm). Image courtesy of Egenolf Gallery.*

and international travelers. The cats of Aoshima in the Seto Inland Sea, which are currently estimated to outnumber humans at a rate of thirty-six to one, are said to be the descendants of ships' cats. There are train station cats, police cats, and store cats that draw tourist dollars and community goodwill. Sites connected with cat folklore like Gōtokuji temple and Imado shrine have also emerged as destinations for ailurophile pilgrimage.

Japan's captivation with cats began well before the reign of Kitty. The earliest surviving diaries—penned over 1000 years ago—contain poignant accounts of pet cats that resonate with the feelings of anyone who has shared their life with an animal today. These indicate that humans formed emotional bonds with pets, independent of their value for controlling vermin.

But it was not until the Edo period (1615–1868) that cats began to proliferate in visual culture. This time of relative peace and stability in the Japanese archipelago saw the development of large cities, including Edo (modern-day Tokyo), the emergence of a highly literate proto-middle class, and an information revolution built upon commercial woodblock printing. One of its chief components was ukiyo-e, or "pictures of the floating world," which account for most of the images in this book. Issued in editions of hundreds or even thousands, ukiyo-e were relatively affordable for ordinary people. They were produced by designers, block carvers, and printers working under the direction of private publishing houses. Reflecting gendered divisions of labor that have proved unfortunately resilient into the present, the named participants were almost exclusively male. Made by and for commoners, ukiyo-e defined, reflected, and elaborated on what was popular on the street, in literature, and on stage.

Among these we find a great number of images of cats in connection with rodent control—which is thought to be the primary mechanism that brought humans and felines together. By the time of the Edo period, cats were thoroughly domesticated, but the rising economic value of sericulture and the damage wrought by rats feasting on silkworms made cats indispensable.

At the same time, the people of Japan found

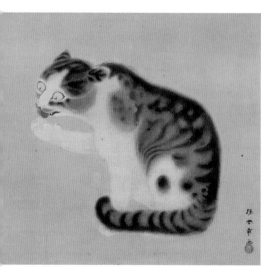

Katsukawa Shunshō, 1726–1793. *Cat Licking its Paw, ca. 1789–92. Hanging scroll, ink and color on paper, 15⅞6 x 20⅜6 in (39.2 x 51.7 cm). The British Museum. © The Trustees of The British Museum.*

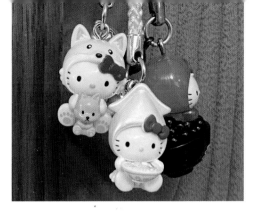

Hello Kitty cell phone strap accessories representing local specialities of Gotochi city, Hokkaido prefecture.
The Gotochi Kitty is a tiny souvenir featuring Hello Kitty in the guise of a regional attraction or meibutsu. A braided cord allows it to be attached to a cell phone. The three illustrated represent squid noodles, salmon roe on rice, and the Ezo red fox from Hokkaido prefecture. The product was first launched in Hokkaido in 1998 and soon diversified to promote other domestic locales. There are now over 3000 varieties, including Gotochi Kitty for cities outside of Japan.

that, beyond simple pragmatic reasons, cats were pleasant to have around. Clean and self-contained, they were welcomed indoors. Meanwhile, all but the smallest and most docile dogs were banished outside, and rarely appear in interior scenes. Because cats have limited tolerance for noise and disruption, a contented moggy napping by the hearth suggests peace and quiet at the end of the day, in a comfortable and cultivated home.

Aside from their immediate appeal, images of cats may contain hidden messages. Like many other animals in East Asia, cats are vessels that are filled with figurative meanings and auspicious wishes, some received from the symbolic vocabulary of China, others of indigenous derivation. Ukiyo-e in particular draws liberally, often via kabuki storylines, from Japan's rich repositories of folklore, fairy tales, and truly unsettling ghost stories with feline protagonists. In Japan, as in the West, cats tend to be associated, sometimes unflatteringly, with women, femininity, and female sexuality.

Artists and their audiences were also enchanted by cats in their own right, or at least what they imagined that to be. They were, as we are today, cap-tivated by the beauty, poise, lithe athleticism, and expressive range of cats. They enjoyed recognizing themselves in their furry companions, while laughing at their weirdness. Projecting complex emotions and motives on them, humans saw cats as romantic heroes, haughty aristocrats, intrepid adventurers, and pleasure-seeking bohemians. But interacting with cats also brings us down to their eye-level. Many of the artworks in this book invite us to experience the world differently, to appreciate the warmth of a sunbeam, to traverse a jungle of onions, or peer closely at a spider.

This book approaches the many lives of cats through Japanese art, reflecting their intertwined history with humans, how they were socially constructed, and the emotional bonds that tie us to them. Our shared affection for cats is such that the appeal of many of these images transcend cultural and societal difference. No other animal invests resources and emotions into the upkeep of another species, even treating them like their own offspring, without pragmatic reasons; as such, the practice of keeping pets both affirms the uniqueness of humans and complicates the notion of our personhood.

Majestic Mousers

Enter the Cat

Across the globe, wherever humans abandoned nomadic life and settled into villages, grew crops, and stockpiled food and seed, they created new ecological niches for rodents. These furry interlopers gnawed their way into our pantries, spread diseases, and shredded precious clothing, bedding, and documents to build their nests.

At some point in Japan's history, cats made themselves useful to humans by controlling rodent populations to the degree that their presence began to be tolerated, and then even welcomed, in homes. The discovery of the skeletal remains of small felines, possibly *yamaneko*—"mountain cats" endemic to East Asia—in archaeological sites from the Jōmon era (ca. 10,500–300 BCE) suggests that cats have lived in close proximity to humans for millennia. These may be the ancestors of critically endangered wild felids, the Tsushima leopard cat and the Iriomote mountain cat. Bones recovered from the Yayoi period (300 BCE–300 CE) Karakami ruins on Iki Island, Nagasaki prefecture, are accepted as being the oldest known belonging to housecats (*Felis catus*). The *karaneko*, meaning "Chinese cat" or "Tang cat" because of its exotic pedigree, is believed to have arrived in Asia from Egypt, and thence to Japan on ships from China

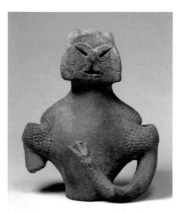

or Korea carrying Buddhist scrolls to protect their precious cargo during the Nara period (710–794) or early Heian period (794–1185).

Urbanization and the rise of sericulture in rural areas during the early modern period favored the proliferation of rodents. Authorities responded to periodic plagues of rats or mice (in Japanese, both are called *nezumi*, so it usually isn't clear which critter is being blamed) with policies involving cats. In 1602, Kyoto's cat owners were supposedly commanded to unleash their pets, thus putting their killer instincts to the service of the city. These laws were coupled with prohibitions over the buying and selling of cats, presumably to prevent commodification and/or theft interfering with their civic duties. The fifth shogun Tokugawa Tsunayoshi (1646–1709), known pejoratively as the "dog shogun" for his animal welfare policies, again forbade the leashing of cats in 1685.

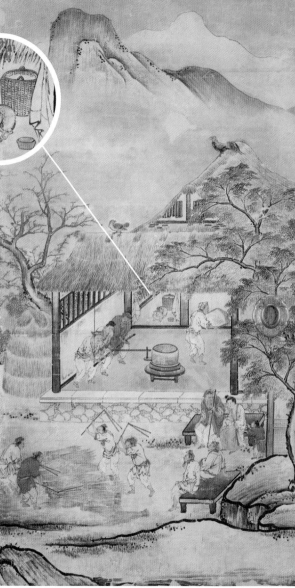

RIGHT **Attributed to Kano Sanraku, 1559–1635.** *Fall, from the set* Rice Farming in the Four Seasons, *1620s. Painting mounted as sliding door panels; ink, light color, and gold on paper, 76 x 39¼ x 4 in (193.04 x 99.7 x 10.16 cm). Minneapolis Institute of Art, The William Hood Dunwoody Fund and gift of funds from Louis W. Hill, Jr.*

BELOW **Kawanabe Kyōsai, 1831–1889.** *Cat and Rat under a Bow Moon, 1871–89. Woodblock print, ink and color on paper, 15⅛ x 10 in (38.5 x 25.5 cm). Published by Sawamuraya Seikichi. Israel Goldman Collection, London. Photo: Art Research Center, Ritsumeikan University.*

OPPOSITE **Dogu figure with feline visage, 3000–2000 BCE.** *Excavated from Kamikurokoma, Yamanashi Prefecture. Earthenware, 10 in (25.4 cm) high. Tokyo National Museum, Gift of Mr. Miyamoto Naoyoshi.*

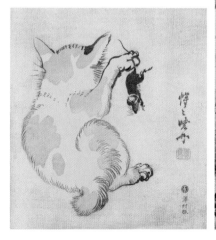

The Book of Cats

Buddhists may have felt somewhat conflicted about the use of cats to control rodents, or were at least aware of the contradiction between their religion's emphasis on compassion and inter-species reincarnation and the cold-blooded treatment of these small but sentient creatures. *The Book of Cats* (*Neko no sōshi*), an example of an *otogi-zōshi*

or fable, is premised on the aforementioned edict of 1602 ordering the people of Kyoto to unleash their cats. Delighted by their new freedoms, the cats

Cats enjoying newfound freedom. *Illustration from The Book of Cats (Neko no sōshi), ca. 1716–36. Woodblock printed book; ink on paper, 6¼ x 9 in (16 x 23 cm). Waseda University Library.*

Chapter One

ventured out into the unexplored city, terrorizing the rodent population.

In the city there lived a Buddhist priest. One night, in his dream, a mouse appeared before him, complaining that his brethren were living in misery because of the cats, and appealing for help. The priest, with little sympathy, suggested that the mice change their parasitic habits so that they might alter their karmic status.

The following night, the priest dreamed that a cat came to him. The priest commanded the cats to cease killing and eating mice, and stick to a diet of rice and fish instead. The cat dismissed this order. Why should cats renounce the source of nourishment that the gods had intended for them?

The mouse appeared to the priest a final time and announced that the mice had no choice but to flee the city. The tale concludes with the mice planning their move to the countryside, where they would live off rice and potatoes from the fields.

The cat appearing before the priest. *Illustration from The Book of Cats (Neko no sōshi), ca. 1716–36. Woodblock printed book, ink on paper, 6¼ x 9 in (16 x 23 cm). Waseda University Library.*

Cats and Sericulture

"Every house must have a good cat."
—Nomoto Dōgen, *Methods of Sericulture* (*Kogai yōhōki*, 1702)

"Households engaged in sericulture should absolutely keep a good cat—two or three cats for a large household, and one for a small household. Cats are essential for preventing rats. There are various methods of rat control, but nothing beats the convenience of a cat."
—Yoshida Shikei, *Handbook on Sericulture Fundamentals* (*Yōsan suchi*, 1794)

Sericulture became a major cottage industry in the Tōhoku region in northern Japan and Nagano prefecture in central Japan between the 18th and early 20th centuries. Silkworms, however, made irresistibly tender and nutritious meals for rodents. They devoured the grubs and gnawed through silk cocoons to reach the pupae inside.

Sericulture experts such as Yoshida Shikei, quoted above, and Kamigaki Morikuni, the author of *Secret Notes on Raising Silkworms* (*Yōsan hiroku*, 1803), advised farmers to keep cats to mitigate this menace. During plague years, demand for cats drove their

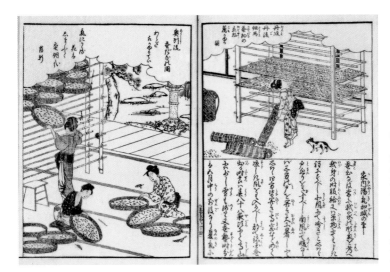

Kamigaki Morikuni, 1753–1808 with illustrations by Nishimura Chūwa and Hayami Shungyōsai, 1767–1823. *Secret Notes on Raising Silkworms (Yōsan hiroku), 1803. Published by Suhara Yaheizaemon. Woodblock printed book, ink on paper, approx. 10¼ x 6⅝ in (26 x 17 cm). Waseda University Library.*

market price up to hair-raising heights. In 1791, the political advisor Mizuno Tamenaga marvelled that cats of "superior" class were being sold for seven gold *ryō* and two *bun*, "regular" cats for five *ryō*, and kittens for two or three *ryō* each (*Yoshino zasshi*). At that time, a gold *ryō* was equivalent to one hundred and fifty kilograms of rice—the amount of rice needed to feed a person for a year. In 1821, rats devouring silkworms in northern Japan allegedly sent prices skyrocketing again to five *ryō*—five times the value of a horse (Matsuura Seizan, *Kashi yawa*).

Reflecting their perceived importance to this industry, scenes of sericulture depicted in 19th century woodblock prints often include cats. In a print by Yoshikazu, a bob-tailed cat inspects a tray of newly hatched silkworms, while its mistress brushes uneaten mulberry leaves from a tray of grubs with a feather. Because sericulture was considered to be "women's work," artists of woodblock prints typically approached the theme through the lens of *bijin-ga*, or "beauty pictures," thus reinforcing the cultural association between female and feline, which will be discussed in further depth later in this book. Female cats with black and white markings, like the one in Yoshikazu's picture, and *mike* or three-color-coats, meaning white, orange, and brown or black, were thought to be keen mousers. Male cats, on the other hand, especially tabbies (called *toraneko* or tiger-cats), were considered to lack aptitude.

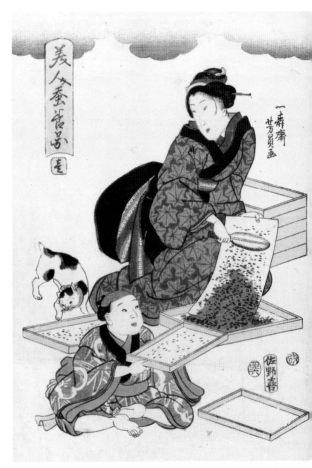

Utagawa Yoshikazu, active ca. 1850–1870. *Pictures of Beauties Raising Silkworms, No. 1, 1855. Published by Sanoya Kihei. Woodblock print, ink and color on paper, 13⅛ x 8¾ in (33.3 x 22.3 cm). The Silk Weaving Nishiki-e Collection, Nature and Science Museum, Tokyo University of Agriculture and Technology.*

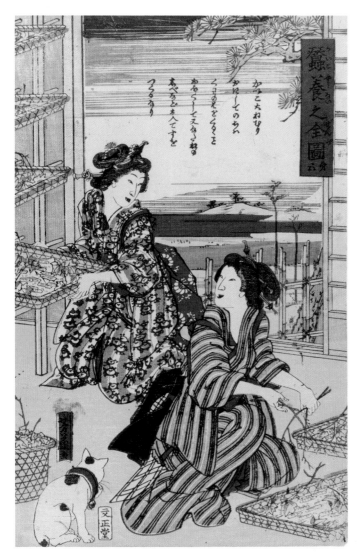

Utagawa Yoshifuji, 1828–1887.
Complete Pictures of Raising Silkworms, No. 5, 1877. Published by Kobayashi Taijirō. Woodblock print, ink and color on paper, 14⅜ x 9¹¹⁄₁₆ in (36.4 x 24.6 cm). The Silk Weaving Nishiki-e Collection, Nature and Science Museum, Tokyo University of Agriculture and Technology.

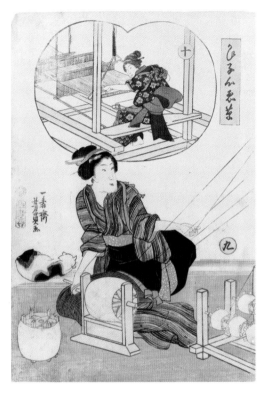

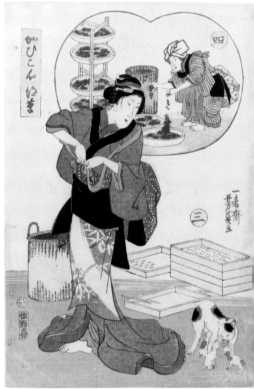

Mouser Mojo

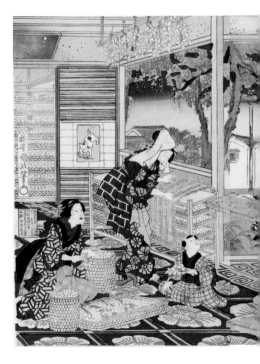

For those who did not want or could not afford a cat, the talismanic power of the feline image could be put to work. Around the 1770s, in response to appeals from silk farmers for help with rodents, the feudal lord Nitta Iwamatsu Atsuzumi in present day Gunma prefecture began creating simple ink paintings of cats to ward off rats. The next three generations of Nitta family heads continued to produce these so-called "Nitta *neko*."

Entrepreneurs, as always, found opportunity in crisis. The writer Ōta Nanpō (1749–1823) reported that around 1781–1801, a monk by the name of Hakusen had begun selling pictures of cats and tigers that supposedly had the power to repel rodents. Various shrines in Japan's "silk belt" produced and sold simple woodblock printed amulets, called *ofuda*, with pictures of cats for repelling rodents.

The design above by Kunimasa IV depicts women undertaking various tasks of the silk cultivation process—collecting eggs, chopping fresh mulberry leaves, and sorting, boiling, and unravelling the cocoons (these would actually take place over several weeks). Casting their protective powers over this scene are Manari Myōjin, the tutelary deity of sericulture, whose likeness is painted on a scroll on the right, and a cat catching a rat on an amulet pasted to a door on the left.

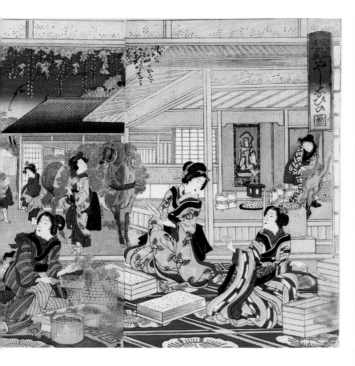

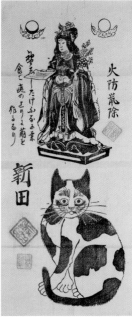

ABOVE **Utagawa Kunimasa IV (1848–1920).** *Pictures of Raising Silkworms, 1888. Published by Tsunashima Kamekichi. Triptych of woodblock prints, ink and color on paper, 14⅝ x 28¾ in (37.1 x 73.1 cm). The Silk Weaving Nishiki-e Collection, Nature and Science Museum, Tokyo University of Agriculture and Technology.*

FAR LEFT **Iwamatsu Atsuzumi, 1738–1798.** *Nitta neko, ca. 1770–1797. Painting mounted as hanging scroll, ink and color on paper, 12⅜0 x 13¹⁵⁄₁₆ in (32.5 x 35.5 cm). Nittaso History Museum.*

RIGHT ABOVE **Possibly after Nitta Sadayasu, dates unknown.** *Fire and Mouse Protection Amulet, ca. 1890–90s. Woodblock print, ink and color on paper, 25⅝ x 11⅝ in (65.2 x 29.5 cm). Nittaso History Museum.*

RIGHT BELOW **Utagawa Kuniaki II, 1835–1888.** *Poem of Repelling Silkworm Rats, 1885. Published by Arakawa Tōbei. Woodblock print, ink and color on paper, 14½ x 10 in (36.9 x 25.4 cm). The Silk Weaving Nishiki-e Collection, Nature and Science Museum, Tokyo University of Agriculture and Technology.*

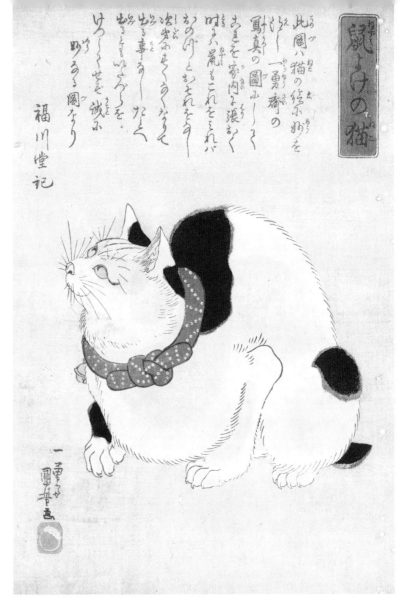

Chapter One

Mouse Prevention Cats

Yellow eyes alert, whiskers and ears pricked to attention, the cat's bony frame contracts, and one paw lifts slightly off the ground as if ready to pounce. The image on the left of a "mouse prevention cat" (*nezumi yoke no neko*) claims to bring instant death to rodents that look upon it. The inscription, signed by the publisher, explains that the image is drawn from life by the skilled artist of cats, Ichiyūsai, also known as Utagawa Kuniyoshi. The collar, handsomely made from tie-dyed silk crepe and threaded with a brass bell, is typical of those worn by cats in Japanese prints, and indicates the wearer's status as a valued member of a household.

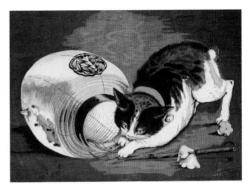

Kobayashi Kiyochika, 1847–1915. *Kitten and Rat in a Lantern, 1877. Published by Matsuki Heikichi. Woodblock print, ink and color on paper, approx. 13¹⁵⁄₃₂ x 18³⁄₁₆ in (34.2 x 46.2 cm). Private collection.*

NEKOGAMI

A number of shrines in Fukushima, Miyagi, and Iwate prefectures have memorial grave markers and stone monuments for cats, and even venerated cats as *nekogami* or "cat gods." The epicenter of this phenomenon is the town of Marumori in Miyagi, which has eighty-one historical stone monuments—more than half of all those known to exist in Japan—that are either sculpted in the form of cats, have images of cats carved into them, or are inscribed with text referring to *nekogami*. The earliest, dated 1810, is also the oldest stone monument in the Tōhoku region. These monuments would seem to signify the high value of cats to sericulture communities. Coupled with the folk wisdom that old cats could become possessed, it is also possible that these memorials appealed to the good graces of the large feline population in the hereafter.

Heroic Cats and Diabolical Rats

The threat rats posed to human health and prosperity magnified their evils in the collective imagination. Japan is replete with tales of monstrous rodents of prodigious size and cunning. Several Edo period bestiaries and anthologies of strange tales describe *kyūso*, or "old rats," that gain supernatural powers upon reaching advanced age. These monstrous beasts are rumored to attack and seduce housecats and father litters of kittens.

The Cat's Uncanny Technique is a humorous tale that appears in a collection of satirical essays on swordsmanship, *The Hayseed Taoist* (*Inaka Sōshi*, 1727) by Issai Chozan (1659–1741). A swordsman called Shōken was tormented by a large rat in his home. He managed to corral the intruder into one room and sent his cat in to dispatch it. But the rat sprung at the cat's face, and the cat fled yowling. Shōken then recruited the renowned mousers of the neighborhood and released them into the room. One cat approached confidently, but the rat again launched itself at the cat and sank its teeth into its flesh. The other cats retreated in horror. Enraged, Shōken stormed in, thrashing at the rat with a wooden sword, but the rat darted away from him, and he succeeded only in smashing the room to pieces.

Shōken remembered hearing of an elderly cat in a neighboring district that had a reputation for being a first-rate mouser and sent his servant to engage its services. When the servant returned, Shōken was

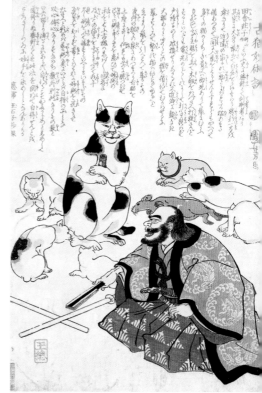

Utagawa Kuniyoshi, 1798–1861. *The Old Cat's Uncanny Technique, ca. 1847–48. Published by Tamaya Sōsuke. Woodblock print, ink and color on paper, approx. 15⅜ x 10⅝ in (39 x 27 cm). Tokyo Metropolitan Library.*

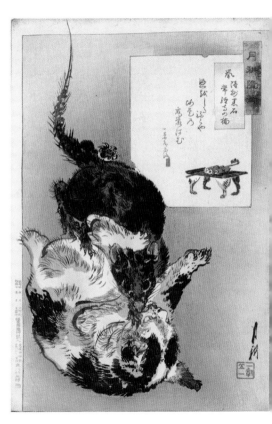

Ogata Gekkō, 1859–1920. *The Rat of Kuroishi in Mutsu Province, and the Cat of Jōkyō-ji Temple, from the series Gekkō's Miscellany, 1896. Published by Matsuki Heikichi. Woodblock print, ink and color on paper, approx. 15⅜ x 10⅝ in (39 x 27 cm). National Diet Library, Tokyo.*

unimpressed—the cat looked no different to the other cats. But when he put the cat in the room, the rat froze in fear. The cat calmly walked over, seized the rat in its mouth, and dragged it away.

Awed, the other cats gathered at Shōken's home and implored the old cat to share its secret technique. "We are all known for bravery and guile, but we have never encountered such terrible rat! We were no match for it, and yet you defeated it so easily!" A discussion ensued and the old cat expounded the principles of the Way of Martial Arts (*budō*), referencing Mencius, the *Book of Changes* (*I Ching*), and Zen thought, to his attentive audience. In Kuniyoshi's print (left), the old cat clutches a handscroll between its paws—a Tiger Scroll (*tora no maki*)—a book of strategy originally for warriors.

Ogata Gekkō's image, on the right, of gigantic rat locked in combat with a cat is connected with a version of a tale from northern Japan recorded by the folklorist Yanagita Kunio (1875–1962). Long ago, in the village of Kuroishi, there was a temple called Shōhōji. Many priests had served there, but each of them had been devoured by demons, and the temple remained empty. One day, an itinerant priest passing through the village asked to stay the night in the temple. Aware of possible dangers, he hid himself under a large pot before falling asleep. During the night, the demons came out dancing and shouting, searching for the human flesh they could smell. As they crashed through the temple, they

sang, "Don't tell Denjōbō in Tanba-no-kuni." But they were unable to find the priest, and eventually left.

The next morning, the villagers arrived at the temple, and were surprised to find the priest alive and well. They invited him to take over the temple. He agreed on the condition that he could travel to Tanba-no-kuni to recruit the help of Denjōbō—who turned out to be a cat.

Upon assessing the situation, Denjōbō explained that the demons were the ghosts of old rats, and he would need the help of his brother to exterminate

Illustrated by Suzuki Kason, Japanese, 1860–1919; rendered into English by Lafcadio Hearn, Japanese, 1850–1904. *Japanese Fairy Tale: The Boy Who Drew Cats, first published 1899; this edition 1920s. Published by Hasegawa Takejirō and Martin Hopkinson & Company, LTD. Woodblock printed book (chirimen-bon), ink and color on crepe paper with silk cord binding, 7¹¹⁄₁₆ X 5⅜ in (19.5 x 13.7 cm). The John and Mable Ringling Museum of Art, Gift of Charles and Robyn Citrin, 2018.*

them. So Denjōbō set out to find him, and in his absence, the priest hung a picture of the cat in the temple as a substitute of his presence. After ten days, Denjōbō returned with his brother, and the two cats killed the rat demons, but in doing so lost their own lives. The priest gave the cats a proper burial and made a stand for Buddhist scrolls from the legs of the rats, as shown in Gekkō's print.

A related story is retold by Lafcadio Hearn, a Greek-born journalist and writer who settled in Japan in 1890, eventually becoming a Japanese citizen. In this fairy tale, a gifted young artist sought shelter in an abandoned temple, unaware that it was haunted by a giant rat. Before going to sleep, he calmed himself by painting cats on a folding screen. During the night, a terrifying commotion shook the building. When morning broke, the boy found the room in disarray and an enormous rat disembowelled on the temple

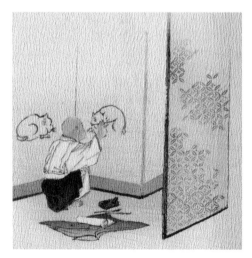

floor. The cats he painted the night before had bloodstains on their faces and paws.

The Boy Who Drew Cats is one of a series of twenty books of fairy tales for young English-language readers conceived by the publisher Hasegawa Takejirō (1853–1938). Hasegawa commissioned Western writers and translators such as Hearn to pen the books, and local artists, including Suzuki Kason, to create illustrations. The books were beautifully produced using deluxe materials. Crêpe paper was used in slightly later editions, such as this volume. The books were a great success and continued to be printed well into the 20th century.

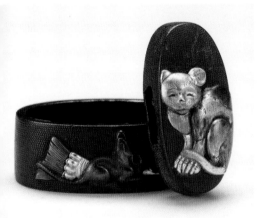

TOP **Kobayashi Kiyochika, 1847–1915.** *The Cat with One Hundred Eyes in Eight Directions. Published by Matsuki Kihei. Woodblock print, ink and color on paper, 14⁹⁄₁₆ x 10⁷⁄₁₆ in (37 x 26.5 cm). Image courtesy of Shukado Gallery.*

ABOVE **Sword hilt collar and pommel (*fuchi-kashira*) with cat and rat, ca. 18th century.** *Copper-gold alloy (shakudō), gold, silver, copper. Minneapolis Institute of Art, Bequest of Louis W. Hill, Jr.*

THE PURR-FECT WEAPON

During the relative peace of the Edo period (1615–1868), a samurai's weaponry shifted from being essential military equipment to statements of wealth, allegiance, and personal taste. Part of his wardrobe were matching sword furnishings, including a *fuchi*, a collar that fits over the base of the grip of the hilt, and *kashira*, a cap that covers the pommel of the hilt. This set has a decoration of a cat with half-closed eyes, and a rat with a broom. When fitted on the sword, the rat would appear to be looking up at the dozing cat.

Feline Fishers, Insect Catchers and Art Critics

Cats' priorities, of course, are not always aligned with those of people. The hunting instincts that have made them valuable to humans are also turned against harmless animals, proving disastrous for biodiversity in many parts of the world. In more innocent times, artists created light-hearted genre scenes of curious cats stalking spiders, dipping paws into fishbowl, and pouncing on hapless frogs.

The two prints on the following pages of cats attacking painted images of butterflies and chickens offer intriguing variations on this theme. Kuniyoshi's design depicts a young woman, the daughter (ca. 1006–1021) of the courtier and renowned calligrapher Fujiwara no Yukinari (972–1027), seated at her desk. The unnamed daughter was herself an accomplished calligrapher. According to the inscription, Yukinari's daughter drew butterflies that were so lifelike that her cat, which had hitherto been seated quietly in her lap, suddenly launched itself at them, upsetting her brush pot and tearing the paper. This apocryphal anecdote may be related to an episode recorded in *Sarashina Diary* (ca. 1059). The author, who had been given a copybook of Yukinari's daughter's handwriting to use as a model, became convinced that a lost cat that she and her sister adopted (or perhaps catnapped) was the reincarnation of Yukinari's daughter, who had recently died of smallpox.

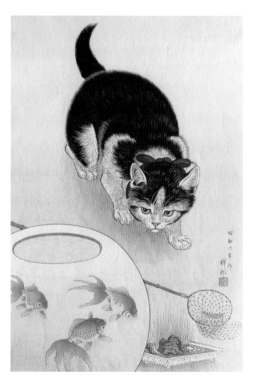

Ohara Shōson, 1877–1945. Cat by Goldfish Bowl, 1931. Published by Watanabe Shōzaburō. Woodblock print, ink and color on paper, 14⅜ x 9⅜ in (36.5 x 23.8 cm). Chazen Museum of Art, Bequest of John H. Van Vleck.

The scene of cat and butterflies also recalls the fabled competition between rival artists Zeuxis and Parrhasius described in Pliny's *Natural History*, written in the 1st century CE. Zeuxis painted a picture of grapes that was so realistic that birds flew up to peck at it. Parrhasius responded with a painting of a curtain so convincing that Zeuxis requested it to be pulled back so he could view his rival's challenge, and was thus beaten at his own game. While we cannot be sure that Kuniyoshi was familiar with Pliny's

ABOVE **Isoda Koryūsai, 1735–1790.** *Cat Dipping a Paw in a Goldfish Bowl, ca. 1774. Woodblock print, ink and color on paper, 10 1/16 x 7 1/2 in (25.6 x 19.1 cm). Museum of Art, Rhode Island School of Design, Providence, Gift of Mrs. Gustav Radeke.*

LEFT **Oide Tōkō, 1841–1905.** *Cat Watching a Spider, ca. 1888–92. Album leaf, ink and color on silk, 14 3/4 x 11 in (37.5 x 27.9 cm). The Metropolitan Museum of Art, Charles Stewart Smith Collection, Gift of Mrs. Charles Stewart Smith, Charles Stewart Smith Jr., and Howard Caswell Smith, in memory of Charles Stewart Smith, 1914.*

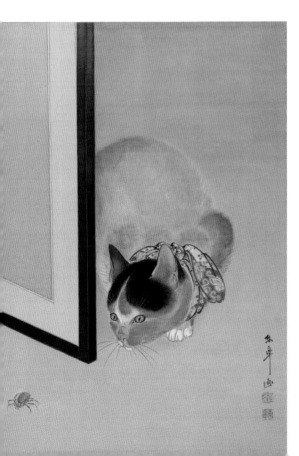

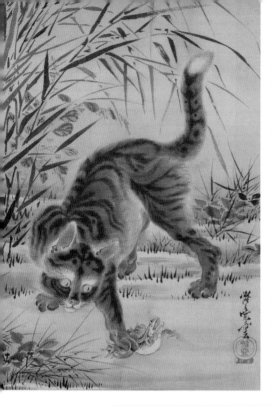

story, Kiyochika, working almost half a century later, likely was. During the 1870s, he began creating designs that simulate the realism and formal qualities of Western-style painting, photography, and printing technologies, seeking to discover whether woodblock print could meet modern demands for objective representations of the world. The white cat clawing at the oil painting of chickens in his print seems to assert that they can.

LEFT **Kawanabe Kyōsai, 1831–1889.** *Cat Catching a Frog, ca. 1887. Album leaf, ink and color on silk, 14⅛ x 10⅝ in (35.9 x 27 cm). The Metropolitan Museum of Art, Charles Stewart Smith Collection, Gift of Mrs. Charles Stewart Smith, Charles Stewart Smith Jr., and Howard Caswell Smith, in memory of Charles Stewart Smith, 1914.*

BELOW **Kobayashi Kiyochika, 1847–1915.** *Cats and Canvas, ca. 1879–1881. Published by Matsuki Heikichi. Woodblock print, ink and color on paper, 9½ x 14¼ in (24.13 x 36.2 cm). Los Angeles County Museum of Art, Gift of Carl Holmes.*

OPPOSITE **Utagawa Kuniyoshi, 1798–1861.** *The Daughter of Dainagon Yukinari, from the series Stories of Wise Women and Faithful Wives, ca. 1841–42. Published by Ibaya Sensaburō. Woodblock print, ink and color on paper, approx. 15⅜ x 10⅝ in (39 x 27 cm). Image courtesy of Egenolf Gallery.*

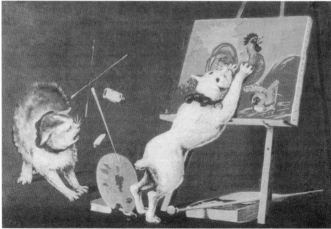

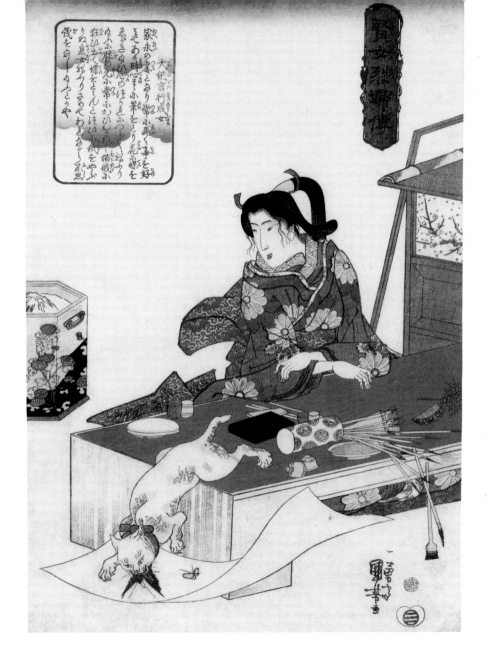

賢女烈婦傳

Domestic Companion or Household God?

Royal Pets

*The cat who lived in the palace had been awarded the headdress
of nobility and was called Lady Myōbu. She was a very pretty cat, and
His Majesty saw to it that she was treated with the greatest care.*
—Sei Shōnagon, *The Pillow Book* (1002), trans. Ivan Morris (1967)

Cats became useful to humans by deterring vermin, but not content to be mere livestock, they sidled their way into homes, hearths, and laps. As pets, they enjoyed a reliable supply of food, shelter and warmth, and safety from larger predators. Their more endearing qualities—congenial personalities, playful antics, discreet habits, and silky, warm bodies—made them valued members of the household. Life, we discovered, was better with cats.

Chronicles and literature from the Heian period (794–1185) indicate that felines were cherished by the nobility for their looks, athleticism, and in the belief that they were sensitive creatures attuned to the moods of their human companions. While cats may have served as furry status symbols and soft currency in the economy of political favor, it is clear that some of these cat-fancying aristocrats formed complex emotional bonds towards them. The earliest record of a cat being kept as a pet is in the journal of the then 22-year-old Emperor Uda (866–931), which is also the oldest extant Japanese court diary. On March 11, 889 CE, the young emperor wrote:

As I have a moment of free time, I would like to write about my cat. This black cat of mine was a gift to the former emperor [Emperor Kōkō, Uda's father] from Minamoto no Kuwashi at the end of his service.

The color of her fur is most unusual. Other cats' fur is an ashy black, but this cat's fur is deep black, like ink. Her length is about one shaku six sun (17⅝ in/45 cm), and her height is about six sun (7¹⁄₁₆ in/18 cm).

When she curls up tightly, she becomes very small, like a black millet seed, and when she stretches, she is long like a drawn bow.

Her pupils sparkle like needles and her ears stand up straight and stiff like spoons. When she crouches, she becomes round and you cannot see her feet or tail, and she looks like a jewel from a cave. When she walks, she moves silently, like a black dragon above the clouds.

She has a natural preference for Daoist mind and body practices and performs the "five bird exercises." She holds her head and tail close to the ground, but when she arches her back, she rises to a height of about two shaku (23⅝ in/60 cm). Perhaps the beautiful luster of her coat is due to her Daoist exercise regime.

She is more skilled at catching mice at night than other cats.

My father kept the cat for a few days before giving

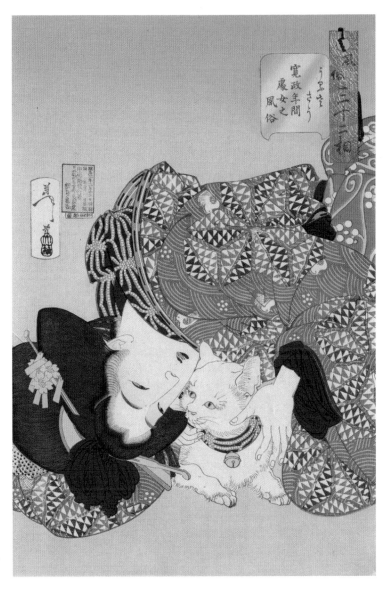

Tsukioka Yoshitoshi, 1839–1892. *Appearing Tiresome, Behavior of a Maiden of the Kansei Era, February 1888. Published by Tsunajima Kamekichi. Woodblock print, ink and color on paper, 14¹¹⁄₁₆ x 10 in (37.31 x 25.4 cm). Minneapolis Institute of Art, The Mary Griggs Burke Endowment Fund established by the Mary Livingston Griggs and Mary Griggs Burke Foundation, gifts of various donors, by exchange, and gift of Edmond Freis in memory of his parents, Rose and Leon Freis.*

Utagawa Kunisada, 1786–1865. *Woman Playing with Cat, from the series Spring Dawn: A Contest of Beauties, ca. 1820s. Published by Iseya Rihei. Woodblock print (nishiki-e), ink and color on paper, 14�5⁄16 x 10¼ in (36.3 x 26 cm). Museum of Fine Arts, Boston, Nellie Parney Carter Collection— Bequest of Nellie Parney Carter.*

her to me. I have now had her for 5 years, and every morning I give her rice porridge made with milk. I treat her thus not because there is anything particularly special about her, but however small a thing she may be, she was given to me by the former emperor, and so I treasure her.

I once turned to the cat and said, "Your mind contains the forces of yin and yang and your body is perfectly made. You understand me." The cat gave a great sigh and gazed intently at my face, but as if her heart was bursting with emotion, she was unable to utter a word in response.

The court official Fujiwara no Sanesuke (957–1046) recorded in his diary, *Shōyūki*, in 999 that when one of the cats of the imperial palace had kittens, the Ministers of the Left and the Right attended the birth rites, and that a courtier had been appointed as nurse to the litter. This was not, however, customary practice, and Sanesuke noted that the fuss sent ripples of laughter through the court.

Some cats of the imperial palace were granted court ranks. Sei Shōnagon's *Pillow Book* (1002) opens with an anecdote concerning a cat called Lady Myōbu, the first historical record of a cat having a name. Lady Myōbu—who may have been one of the kittens born into the litter mentioned by Sanesuke— held the title of fifth rank and was doted upon by the reigning Emperor Ichijō (986–1011). One day, the cat's nurse, displeased to find her charge basking lazily in the sun, induced one of the palace dogs to attack it. Outraged by this treatment of his beloved pet, the emperor ordered the dog to be beaten and banished and the nurse dismissed from her post.

By the late 17th century, we have evidence of

commoners keeping cats as pets. The German physician and naturalist Engelbert Kaempfer, stationed on the artificial island of Dejima in Nagasaki 1690–92, with no opportunity to observe female aristocrats in their homes, wrote of Japan's pampered felines:

> *They have a particular beautiful kind of Cats [sic]*
> *which is a domestick Animal with them, as with us.*
> *They are of a whitish color, with large yellow*
> *and black spots, and a very short Tail, as if it*
> *has been purposely cut off. They don't care for*
> *mousing, but love mightily to be carried out,*
> *and carress'd chiefly, by Women.*
> Engelbert Kaempfer, *The History of Japan*, vol. 1 (1727),
> trans. J.G. Scheuchzer (1971)

Utagawa Kunisada, 1786–1865. *Woman Playing with Cat, from the series Fabrics to Order in Current Taste, ca. 1843–47. Published by Yamashiroya Jinbei. Vertical diptych of woodblock prints, ink and color on paper, approx. 25¹¹⁄₁₆ x 8¹¹⁄₁₆ in (65.3 x 22.1 cm). National Diet Library, Tokyo.*

Fujiwara no Teika's Beloved Cat

Like the salt seaweed,
Burning in the evening calm,
On Matsuo's shore,
All my being is aglow,
Waiting one who does not come.
—Fujiwara Sadaie, trans. Clay MacCauley (1917)

To illustrate this famous poem of romantic longing by Fujiwara no Sadaie (1162–1241), Kuniyoshi reinterpreted the verse, somewhat irreverently, as expressing the anguished thoughts of a pet owner fretting over a lost or wandering cat. The print imagines the heartfelt homecoming. A nobleman cradles the cat in his arms, pressing his cheek to its fluffy face, while a child carefully prepares a celebratory feast of sashimi for the feline. Standing slightly apart from this scene is the lady of the house, who raises her hand to her mouth in a gesture of surprise or disapproval.

Fujiwara no Sadaie, also called Fujiwara no Teika, was a poet, writer, anthologist, and renown ailurophile. An entry in his diary, *Chronicle of the Bright Moon (Meigetsuki)* from 1207 records that a beloved cat, acquired by his wife, was killed by a dog. The cat, according to Teika, was a rare creature that allowed itself to be carried around and tucked into his sleeves without complaint. His sadness over the cat's death, he observed, was no different to mourning the loss of a person. It is perhaps with this in mind that Kuniyoshi, a fellow cat man, conceived this unusual design.

Utagawa Kuniyoshi, 1798–1861.
Fujiwara no Teika, from the series One Hundred Poems from One Hundred Poets, ca. 1840–1842. Published by Ebisu. Woodblock print, ink and color on paper, 10 x 14¾ in (25.5 x 37.5 cm). National Museum of Ethnology, Leiden.

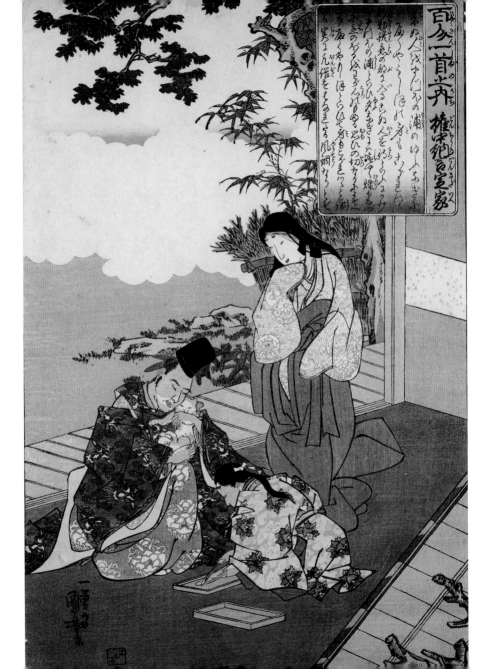

Cosier Together

The addition of a contented cat sets a mood of peace and harmony in a domestic scene. As domestic animals with a reputation for cleanliness, discretion, and conviviality, a preference for order and tranquillity, skills at deterring vermin, as well as the expense of acquiring and keeping them, cats symbolize the comforts of a prosperous, orderly home, even if home is a rented room in a bordello. Artists frequently depicted cats and humans sharing the warmth of a charcoal-burning brazier or *kotatsu*, an ingenious heating device invented in Edo comprising a frame placed over a sunken hearth or a pot and draped with a blanket. Such images often contain a note of gentle humor in the cosy camaraderie between two- and four-legged companions.

In Koryūsai's scene, two young women seated at a *kotatsu* play cat's cradle, or *ayatori*. Oblivious to their game, a black and white cat nestles comfortably under the edge of the quilt. The animal's bewhiskered face seems to radiate with pleasure at finding the best seat in the house.

In Western popular culture, the trope of the "cat lady"—a bookish, single women with a cat or cats— is assumed to be eccentric, possibly deranged, and condemned to a fate of loneliness and isolation. With luxurious clothing and bedding, and a cat for company, however, Yoshitoshi's widow (page 41) seems to be enjoying her independence. Engrossed in her book—perhaps the latest page-turner by Kyokutei Bakin—the woman's lips are slightly parted and a

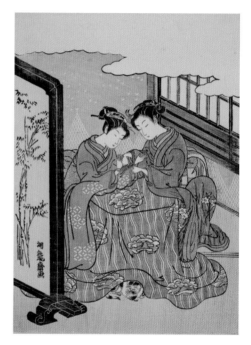

ABOVE **Isoda Koryūsai, 1735–1790.** *Two Young Women Playing Cat's Cradle, ca. 1769. Woodblock print, ink and color on paper, 10¼ x 7¾ in (26.1 x 19.7 cm). Art Institute of Chicago, Clarence Buckingham Collection.*

RIGHT **Tsukioka Yoshitoshi, 1839–1892.** *Looking Warm, An Urban Widow of the Kansei era [1789–1801], from the series Thirty-Two Aspects of Customs and Manners, 1888. Published by Tsunajima Kamekichi. Woodblock print, ink and color on paper, 14 x 9⅜ in (35.6 x 23.8 cm). The Metropolitan Museum of Art, Gift of Lincoln Kirstein, 1985.*

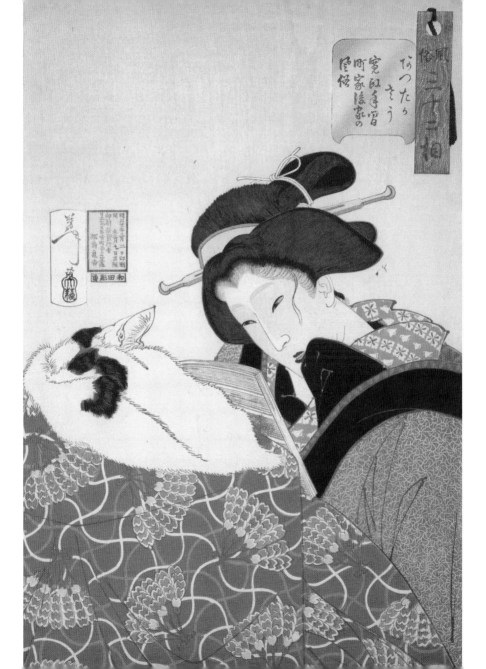

なつたかさう寛政年間町家後家の風俗

LEFT **Yamaguchi Soken 1759–1818.** *People of Yamato (Japan) Picture Album (Yamato jinbutsu gafu), 1800. Vol. 3 of a set of three woodblock printed books, ink on paper, 10⁷⁄₁₆ x 7³⁄₁₆ in (26.5 x 18.3 cm). The Metropolitan Museum of Art, Purchase, Mary and James G. Wallach Foundation Gift, 2013.*

RIGHT **Utagawa Kunisada, 1786–1865.** *Reading Beauty and Stretching Cat, ca. 1820s. Woodblock print, ink and color on paper, 14⅜ x 10¼ in (36.4 x 25.9 cm). Image courtesy of Egenolf Gallery.*

lock of hair has escaped her otherwise neat coif. The realistic treatment of the cat's tightly curled body and pointed ear contrasts with the more stylized depiction of the woman. The delicate texture lines barely visible on the white areas of the animal's fur are achieved using "blind printing" (*karazuri*), whereby the paper is impressed against printing blocks that are carved but not inked to create a three-dimensional pattern.

Above right, on a slow, chilly day at a bookstore on Hikage Street, a scrawny cat rouses itself from its nap, arches its back in a stretch and yawns grotesquely. Its comically distorted countenance provides a foil to the beauty of its mistress, who sits listlessly at a *kotatsu*, a book open before her. Behind her, the neck of a shamisen leans against a wall papered with *surimono*—"printed things" issued by poetry coteries and other literary-minded collectives. Receipt books hang neatly from nails.

In a *surimono* by Kuniyoshi, a calico cat appears to have launched itself on top of the *kotatsu*, startling it mistress and scattering books and a lamp (page 44). The scene is a parody of an episode of the epic novel, *Tales from the Water Margin* (Ch. Shuihu zhuan, Jp.: Suikoden), in which the strongman Bushō (Ch. Wu Song) slays a man-eating tiger after a night of drink-

ing. The humor of the design lies in the substitution of a rambunctious moggy for the ferocious apex predator. The image belongs to a series in which each design likens a young woman to one of the heroes *Tales from the Water Margin*—one of Kuniyoshi's signature themes.

Harunobu's print presents a humorous narrative set in a tea house. A cat, eyes tightly closed, is curled up in the lap of a woman who has nodded off to sleep before a brazier. Her head drops forward heavily, and her comb threatens to tumble into the ashes. Her hand rests on a pair of chopsticks used to stir the coals. Playing a trick on her, her two companions have tied the end of her obi to the pillar behind. The inscribed poem alludes to end of year festivities; the shamisen player silhouetted against the shoji of the neighboring parlor is perhaps entertaining guests at a party to farewell the old year.

RIGHT BOTTOM **Tsukioka Yoshitoshi, 1839–1892.** *I want to Cancel My Subscription, from the series A Collection of Desires, 1878. Woodblock print, ink and color on paper, 14³⁄₁₆ x 9½ in (36.04 x 24.13 cm). Published by Inoue Mohei. Minneapolis Institute of Art, The Mary Griggs Burke Endowment Fund established by the Mary Livingston Griggs and Mary Griggs Burke Foundation, gifts of various donors, by exchange, and gift of Edmond Fries in memory of his parents, Rose and Leon Fries.*

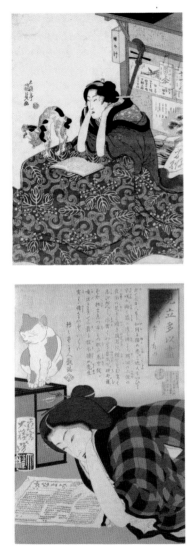

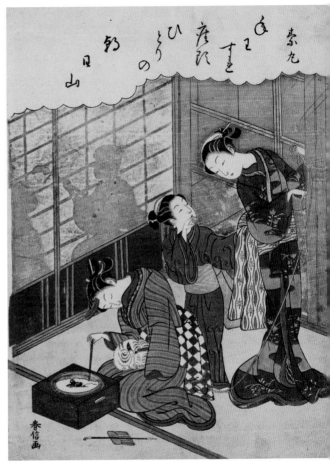

素丸

夕立産沢ひようの釣日山

ABOVE **Suzuki Harunobu, 1725–1770.** *Poem by Somaru, from the series* Fashionable Versions of Ink in Five Colors, *ca. 1768. Woodblock print, ink and color on paper, 11⅛ x 8¼ in (28.2 x 20.9 cm). Museum of Fine Arts, Boston, William Sturgis Bigelow Collection.*

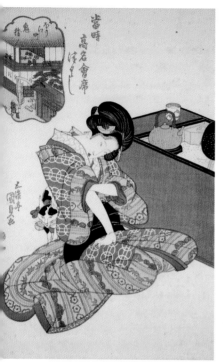

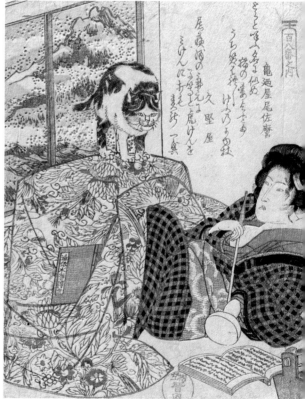

ABOVE **Utagawa Kunisada, 1786–1865.** *The Onikatsu Restaurant in Horiechō, from the series An Assortment of Famous Restaurants of the Present Day, 1818–1824. Published by Yamaguchiya Tōbei. Woodblock print, ink and color on paper, 15¼ x 10⅜ in (38.6 x 26.3 cm). National Museum of Ethnology, Leiden.*

BELOW **Utagawa Kuniyoshi, 1798–1861.** *Bushō, from the series Suikoden of Women's Customs from One Hundred and Eight Sheets, ca. 1832. Woodblock print (surimono), ink and color on paper, approx. 8 x 7 in (21 x 18 cm). Collection of Charles and Robyn Citrin.*

Chapter Two

A MODEL COMPANION

Finely modelled and decorated with a plump body and appealing expression, this ornament of a "loafing" cat emanates a charming feline presence—and is perhaps sufficiently lifelike to startle a mouse. The Sōshichi kilns, where it was created in 1806, were founded by Masaki Sōshichi, a tile maker employed in the building of Fukuoka Castle in 1600. According to legend, he made a figurine from the leftover clay for the feudal lord Kuroda Nagamasa, thus launching a six-generation dynasty of studio ceramicists. He and descendants specialized in making finely potted unglazed articles such as masks, figurines, dolls, tea utensils, and other household articles.

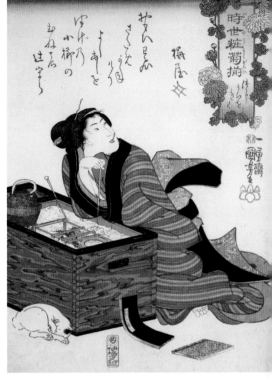

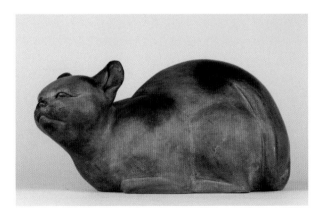

ABOVE **Utagawa Kuniyoshi, 1798–1861.** *Listening for the Fortune-teller, from the series An Assortment of Chrysanthemums in the Modern Style, 1845. Published by Ibaya Senzaburō. Woodblock print, ink and color on on paper, approx. 15⅜ x 10⅝ in (39 x 27 cm). National Diet Library, Tokyo.*

LEFT **Okimono of a Cat, 1806** *Sōshichi ware, earthenware with pigments, 5 x 11⅝ x 6⅜ in (12.7 x 29.5 x 16.2 cm). Image courtesy of Kagedo Japanese Art.*

Cats and Children

Sekino Jun'ichirō's sons Junpei and Yowsaku and daughter Ayuko grew up with dogs, chickens, finches, koi, and cats. His portraits of his children with their pets that pay tribute to the place of animals within the family, and suggest that a young person's relationship with animals reveals something about their nature and burgeoning character. The affection of cats, who tend to be wary of grabbing hands, sudden movements, and loud noise, must be earned through gentleness. A white cat appears at ease in the lap of Yowsaku, a boy with large and sensitive eyes. On the other hand, sometimes such friendships are comically fraught—the yellow tabby with limbs akimbo in *Girl with Cat* appears to be moments from wriggling free of the Ayuko's grasp.

Sekino was an artist of the modernist *sōsaku hanga* or creative print movement, which coalesced in the early 20th century in response to developments in European modernist art. Mostly trained in Western style painting and sculpture, these young artists rejected the collaborative production of ukiyo-e, whereby prints were produced by specialized artisans working under the direction of a commercial publisher, and claimed complete authorship of their work by carving and printing their own designs. During the postwar period, *sōsaku hanga* artists benefited from the patronage of members of the Allied Occupation. New diplomatic ties between the U.S. and Japan provided opportunities for Sekino and his peers to travel abroad to exhibit, teach, and study.

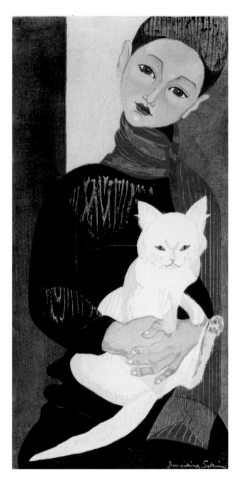

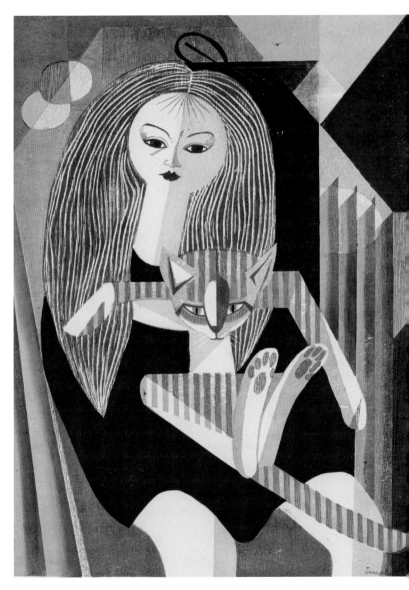

LEFT **Sekino Jun'ichirō, 1914–1988.** *Boy with Cat, 1957. Woodblock print, ink and color on paper, 26¾ x 14⅞ in (68 x 38 cm). The John and Mable Ringling Museum of Art, Gift of Charles and Robyn Citrin, 2015.*

RIGHT **Sekino Jun'ichirō, 1914–1988.** *Girl with Cat (artist's proof), ca.1955. Woodblock print, ink and color on paper, 24 x 18⅛ in (61 x 46 cm). The John and Mable Ringling Museum of Art, Gift of Charles and Robyn Citrin, 2017.*

DOMESTIC COMPANION OR HOUSEHOLD GOD?

Cats in the Garden

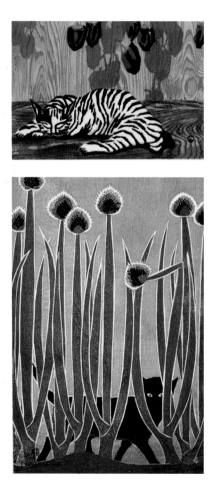

A black and white cat bathes in the golden afternoon sunlight. Persimmon, harvested in autumn, are suspended to dry above, casting shadows on the wall behind. The dried fruit, called *hoshigaki*, are a seasonal delicacy and in the past, a valuable source of nutrition for peasants over the winter months. The play of the woodgrain patterns and the cat's zebra-like stripes animate the design, while the abundant harvest and peacefully napping feline make an auspicious combination.

At right, a little black cat with puppy dog eyes delivers the psychological intensity of the kabuki actor portraits for which the artist is best known. Shunsen was affiliated with the *shin hanga* or "new print" movement, which sought to revive the techniques and period sensibilities of ukiyo-e, primarily for a Western market. However, he demonstrated his versatility as an artist when his publisher commissioned him to create a series of cats and dogs, for which he incorporated elements of the expressive, modernist style of *sōsaku hanga* or creative prints, such as thick outlines and overlapping masses of flat color. The silver halo is achieved through graduated printing (*bokashi*) of the dark background and applications of mica.

TOP LEFT **Yamaguchi Susumu, 1897–1983.** *Cat Basking in the Sun, 1960. Woodblock print, ink and color on paper, 13 x 16⅜ in (33 x 41.6 cm). Image courtesy of Egenolf Gallery.*

LEFT **Kasamatsu Shirō, 1898–1991.** *Onion Flowers, 1958. Woodblock print, ink and color on paper, 16¼ x 11¼ in (41.2 x 28.6 cm). Private collection.*

Natori Shunsen, 1886–1960. *Sitting Black Cat, ca. 1950. Published by Watanabe Shōzaburō. Woodblock print, ink and color on paper with mica, approx. 16 x 10¾ in (40.6 x 27.3 cm). Image courtesy of Egenolf Gallery.*

Fukase Masahisa's Kittens

"I didn't want to photograph the most beautiful cats in the world, but rather to capture their charm with my lens while being reflected in their pupils. One might accurately say that this collection is really a 'self-portrait' for which I adopted the form of Sasuke and Momoe."
—Fukase Masahisa

In 1977, broken-hearted after the collapse of his marriage, artist Fukase Masahisa adopted a tabby kitten. He named the cat after the fictional ninja hero Sarutobi Sasuke, and immediately began photographing it, finding solace and delight in its antics, curiosity, and their quiet moments together. As a subject, Sasuke stimulated Fukase's pursuit of techni-

Chapter Two

cal innovation and psychological depth.

But ten days later, Sasuke vanished. Fukase frantically posted "lost cat" fliers around his neighborhood. A woman who had found a kitten that resembled his lost cat contacted him, but it wasn't Sasuke. Nonetheless, he welcomed it into his home, naming it Sasuke II, and began photographing it too. A year

LEFT **Fukase Masahisa, 1934–2012.** *Untitled (Momoe) from the series Sasuke, 1977–78. Gelatin silver print, 8 x 10 in (20.3 x 25.4 cm).* © *Masahisa Fukase Archives, courtesy of Atelier EXB in Paris.*

ABOVE **Fukase Masahisa, 1934–2012.** *Untitled (Jumping Sasuke) from the series Sasuke, 1977–78. Gelatin silver print, 8 x 10 in (20.3 x 25.4 cm).* © *Masahisa Fukase Archives, courtesy of Atelier EXB in Paris.*

later, Sasuke II was joined by another cat called Momoe, who also appeared in Fukase's photos.

Fukase's photographs stand as a poignant and joyful tribute to the relationship between the artist and his feline companions. He published several images from the series during his lifetime, but this body of work recently shot to fame as the subject of a recent photobook compiled by Tomo Kosuga, founder of the Masahisa Fukase Archives.

Fukase is known for his haunting, semi-abstract images of domestic life, animals, rural landscapes. His photobook *Ravens (Karasu)*, produced between 1975 and 1986, a study in angst, established him as one of the most radical and conceptually rigorous photographers of postwar Japan.

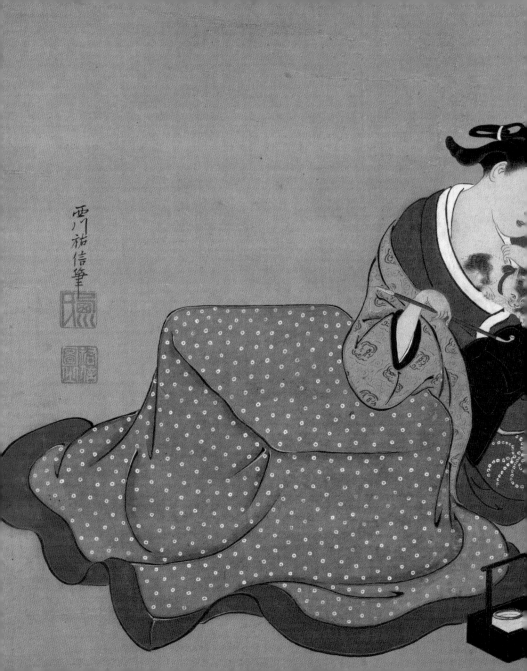

Felines
and Females

Cats and Beautiful Women

Most images of cats are found in the context of *bijin-ga* or "beauty pictures"—wherein the "beauties" are mostly women presented by and for a male gaze. In these works, the animal is often endowed with a dual identity, relating to both the artist/voyeur (who is usually male) and the female subject. The cat's supple, pleasure-seeking body is likened to female sensuality, while the playful kitten may be a symbol of flirtation and illicit desire, and/or the male lover who is teased into a frenzy of lust. The independence and reputed inscrutability of cats is associated with coyness and untrustworthiness, attributes unflatteringly attributed to women. The cat witches of Chapter Six are often dangerous, transgressive women who have rejected social norms.

The Japanese word for cat, *neko*, is slang for prostitute, and is a homonym for a girl (*ko*) who sleeps (*ne*). In imagery related to the pleasure districts of early modern Japan, the intimacy between female and feline perhaps reflects the bitter reality that women working in these contexts may have had few true friends of their own species. As well as providing comfort and companionship, a cat was a silent vessel for whispered confidences. Cats are also associated with prostitutes and female entertainers through the three-stringed shamisen that they played, because the soundbox is covered in catskin.

On the other hand, the relationship is also celebrated and sentimentalized. The quiet domesticity, sweetness, and elegance of a cat symbolizes those qualities in a woman. As mentioned in Chapter One, sericulture, for which cats were useful, was considered to be "women's work," which reinforced the cultural association between female and feline.

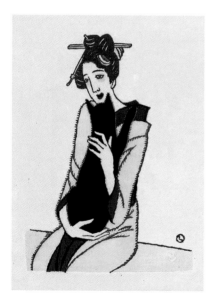

Takehisa Yumeji, 1884–1934. *Woman Holding Black Cat, 1920. Approx. 16⅞ x 11 in (42.8 x 27.9 cm). Private collection.*

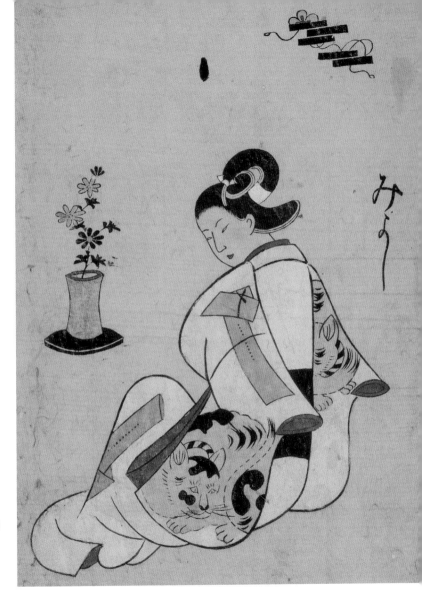

Torii Kiyonobu I, 1664–1729. *Album of Courtesans: Miyoshi, 1700. Published by Hangiya Shichirōbei. Page of a folding album, ink on paper, with hand-applied color, 10⅝ x 7 in/27 x 18 cm (image). Museum of Fine Arts, Boston, William Sturgis Bigelow Collection.*

The Third Princess
and Her Cat

*"To relieve his powerful feelings the Intendant
called the cat and cuddled it, and with its deli-
cious smell and its dear little mew it felt to him
naughtily enough like its mistress herself."*
—Murasaki Shikibu, *The Tale of Genji* (ca. 1010),
trans. Royall Tyler (2001)

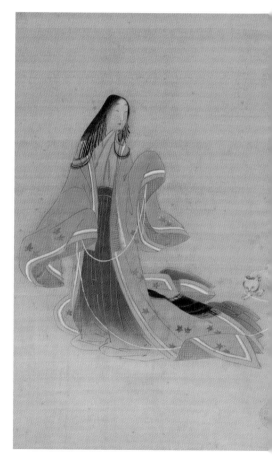

An association between cats and the romantic
female subject was firmly established in the
Japanese cultural cannon by Murasaki Shikibu's
(ca. 978–ca. 1014) epic romance, *The Tale of Genji*.
In a woodblock print by Suzuki Harunobu, a young
woman dressed in courtly attire stands by an open
doorway, holding a pretty cat on a leash. This
combination of motifs alludes to a pivotal episode in
the novel, in which the Third Princess—the new and
ill-matched bride of the aging prince Genji—catches
the eye of the much younger Kashiwagi.

In the book, the princess and her attendants,
screened by bamboo blinds—the bare minimum
demanded by Heian period etiquette—watch a
group of noblemen playing with a ball in the garden
outside her chambers. Suddenly, her Chinese kitten
dashes out, flipping open the blinds and reveal-
ing the princess to Kashiwagi. Instantly smitten, he
pursues the princess, but is rebuffed. He manages
to borrow her cat and dotes upon it as if it were the
princess herself.

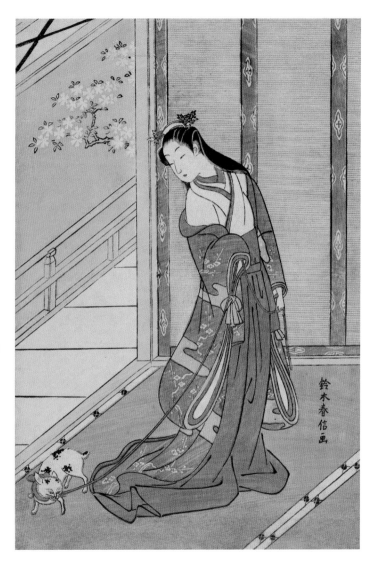

LEFT **Tsukioka Settei, 1710–1786.** *The Third Princess with her Cat, from the "New Herbs I" chapter The Tale of Genji, 18th century. Hanging scroll, ink and color on silk, 34¹³⁄₁₆ x 12 ⁷⁄₁₆ in/88.5 x 31.6 cm (image). The Metropolitan Museum of Art, Mary Griggs Burke Collection, Gift of the Mary and Jackson Burke Foundation, 2015.*

RIGHT **Suzuki Harunobu, 1725–1770.** *Onna San no Miya (the Third Princess), 1768–70. Edo period (1615–1868). Woodblock print, ink and color on paper, 10⅝ x 8 in (27 x 20.3 cm). Museum of Fine Arts, Boston, William S. and John T. Spaulding Collection.*

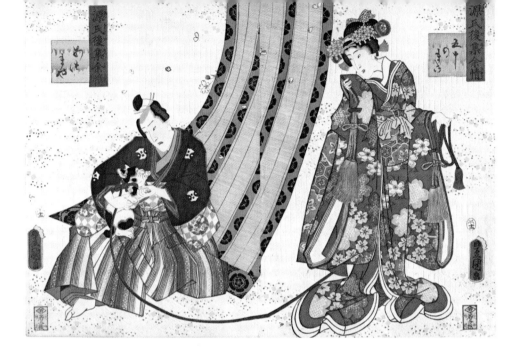

"You I make my pet, that in you I may have her,
my unhappy love:
What can you be telling me, when you come
crying this way?"
—Murasaki Shikibu, *The Tale of Genji* (ca. 1010),
trans. Royall Tyler (2001)

Colluding with the princess's nurse, Kashiwagi steals into her room and rapes her.

The incident, representing gross breaches of social taboos as well as personal betrayal, culminates with Kashiwagi drinking himself to death out of guilt. As an aristocratic woman, the Third Princess is also censured for allowing herself to be seen by another man—an act of wanton negligence—and after

giving birth to Kashiwagi's son, she "retires" from marriage by becoming a priestess. Genji, initially outraged by the whole affair, comes to accept this attack to his honor as karmic retribution for his own youthful indiscretions.

In Japanese imagery, the cat on its leash often appears as visual shorthand to refer to this tragic tale of temptation, infatuation, and transgression. Like many classics, the story was disseminated though popular culture, including the literary spoof *A Fraudulent Murasaki's Rustic Genji* (serialized 1829–42), written by Ryūtei Tanehiko's (1783–1842). Kunisada's diptych above, featuring a morose Kashiwagi clutching the princess's cat, is based on illustrations he provided for these books.

LEFT **Utagawa Kunisada, 1786–1865.** *Chapter 50, Azumaya, from the series "Lingering Sentiments of a Late Collection of Genji," 1858. Published by Wakasaya Yoichi. Diptych of woodblock prints, ink and color on paper, 14¼ x 9¾ in (36.2 x 24.8 cm). The Metropolitan Museum of Art, Gift of Lincoln Kirstein, 1985.*

BELOW **Attributed to Matsuno Chikanobu, active early 18th century.** *The Third Princess and a Cat, from the "New Herbs I" (Wakana I) chapter The Tale of Genji, 18th century. Painting mounted as hanging scroll, ink and color on paper, 31⁷⁄₁₆ x 11⅝ in/79.9 x 29.6 cm (image). The Metropolitan Museum of Art, Mary Griggs Burke Collection, Gift of the Mary and Jackson Burke Foundation, 2015.*

RIGHT **Kitagawa Utamaro, 1753–1806.** *Chiyo from Kaga Province, ca. 1801–04. Published by Murataya Jirōbei. Woodblock print, ink and color on paper, 20½ x 9⁵⁄₁₆ in (52 x 23.7 cm). Minneapolis Institute of Art, Gift of Mrs. Sidney Dean.*

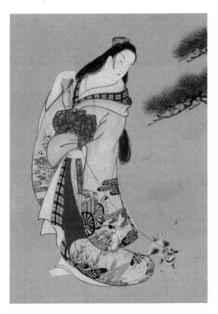

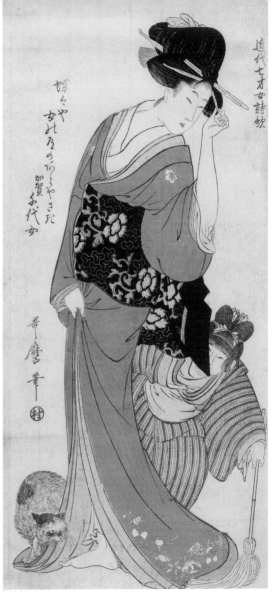

Cats of the Bordello

A hanging scroll by the Kyoto painter Sukenobu imagines a cosy scene of a courtesan entertaining a visitor in her parlor. She leans one elbow against a *kotatsu*. A three-stringed shamisen has been cast aside and utensils for smoking are set on the floor before them. Beyond them, unseen, is her male client. Tucked into the front of her underrobe is a piebald kitten, which she teases with a long-stemmed tobacco pipe. The depiction of the cat's fluffy coat

BELOW **Nishikawa Sukenobu, 1671–1750.** *Courtesan with a Kitten, early 18th century. Hanging scroll, ink, color, and gold on silk, 13⅛ x 20¾ in/33.4 x 52.8 cm (image). The Metropolitan Museum of Art, Gift of Sue Cassidy Clark, in honor of Barbara Brennan Ford, 2020.*

RIGHT **Utagawa Hiroshige, 1797–1858.** *Asakusa Ricefields and Torinomachi Festival, from the series One Hundred Famous Views of Edo, 1857. Published by Uoya Eikichi. Woodblock print, ink and color on paper, 14¹⁄₁₆ x 9⅝ in (35.7 x 24.5 cm). The Metropolitan Museum of Art, Rogers Fund, 1914.*

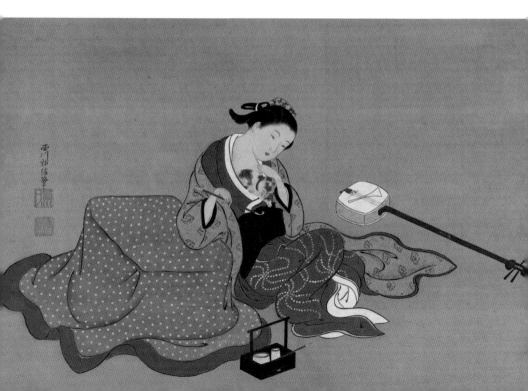

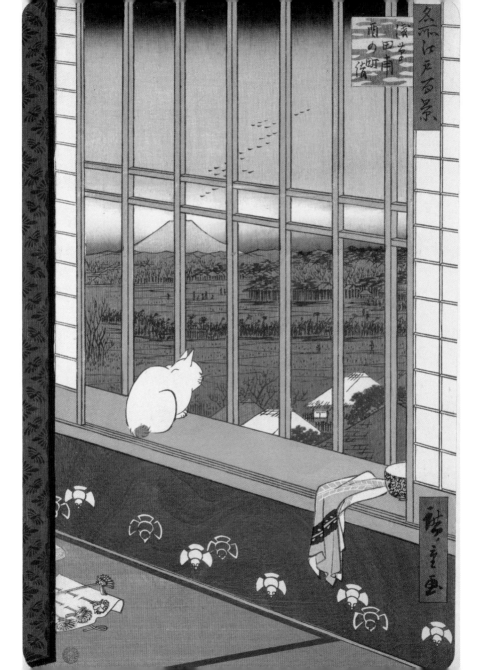

against her bare chest invites the viewer to imagine the softness of fur and skin, and thus draws parallels between the animal and the female body.

The combination of a beautiful woman—such as an elite courtesan—and her feline companion is a popular theme of ukiyo-e. The presence of a pampered pet in a house of assignation cast an air of gentility and luxury that belied the sordid nature of the business that took place there, even, as we saw above, connecting it with the aristocratic world depicted in the *Tale of Genji*. The cat, enjoying intimacy and affection from the female object of desire, can also function as a surrogate for the male subject.

In Hiroshige's print on page 61, the rounded form of a white, bobtailed cat perches calmly on a windowsill, front paws tucked neatly together, ears and whiskers pricked. In the distance, dusk falls on Mount Fuji, Japan's sacred peak. But the cat's attention is directed elsewhere. Below, a procession of tiny stick figures traverses the fields, making its way to the shrine of Washi Daimyōjin, located west of the Yoshiwara, Edo's licenced brothel district, on the occasion of the Torinomachi Festival.

Festival days such as this were big business for the Yoshiwara. Its gates, usually closely monitored by guards, were flung open, and every prostitute was expected to take a customer. In this scene, however, Hiroshige did not depict the woman, but various items around the room hint at her presence, and

what has just taken place there. Poking out from the edge of folding screen, used to divide rooms for privacy, is a packet of hairpins shaped like *kumade*, or "bear paw" rakes—perhaps a gift from her client— which symbolize "raking in" wealth in the year ahead. Beyond them is a bundle of tissue paper, needed for cleaning up after the deed, while a bowl of water and a towel rest on the near corner of the windowsill. For viewers today, it is tempting to read the cat's gaze as signifying the courtesan's wistful longing to be freed from her servitude; however, Hiroshige and his peers rarely dwelt on the oppressive reality of the pleasure industry.

A gaunt, gargoyle-like cat provides a droll foil for the serene loveliness of its mistress in a painting by Hokusai. Something has caught the animal's attention—perhaps the woman's twitching toes—and the little feline seems poised to leap down from its lofty perch in the crook of her arm to investigate. The woman's statuesque figure is emphasized by the narrow, upright format of the painting and the heavy, vertical lines that describe the fall of her robes. Lively counterpoints animate the composition: the tilted heads of beauty and beast, her finery and its silk collar, and the contrast between the forceful, ink brushwork of the drapery with the delicate rendering of the textile patterns, the cat's fur, and the woman's hair, face, and hands. Accents of warm red give vibrancy to the otherwise subdued palette.

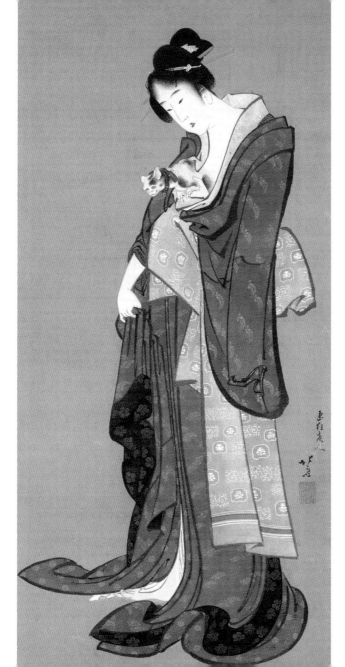

Usugumo's Cat

*In Kyōmachi, a cat prowling for love heads
for Ageyamachi.*
—Takarai Kikaku, 1661–1707

Usugumo was a high-ranking courtesan of the Genroku era (1688–1704) employed at the Miuraya brothel. Prefaced by the short poem above, the inscription of Yoshitoshi's print explains that Usugumo doted upon a cat that never left her side. While entertaining customers, the cat sat on her lap, and when Usugumo went out to meet clients, one of her attendants carried it in her arms. Usugumo is depicted wearing a robe patterned with cats, with a cat-shaped *mon* or crest on her sleeve, and hairpins ornamented with cats at each end.

The brothelkeeper, concerned that rumors of feline sorcery would damage his business, scolded Usugumo, and took the cat away. She immediately fell ill. Alarmed that he would lose money—keeping an elite prostitute entailed significant expenses, and Usugumo was in her prime—the brothel owner returned the cat to its mistress. Usugumo immediately recovered, and even received clients that day.

In other versions of this story, the cat, behaving strangely, followed Usugumo towards the toilet. Suspecting it to be possessed, the brothel cook charged in and lopped off its head with one clean blow of his knife. The severed head shot past and latched its teeth into the body of a monstrous

Ogata Gekkō, 1859–1920. *The Keisei Usugumo, from the series Gekko's Miscellany, 1887. Published by Takekawa Risaburō. Woodblock print, ink and color on paper, approx. 15⅜ x 10⅝ in (39 x 27 cm). National Diet Library, Tokyo.*

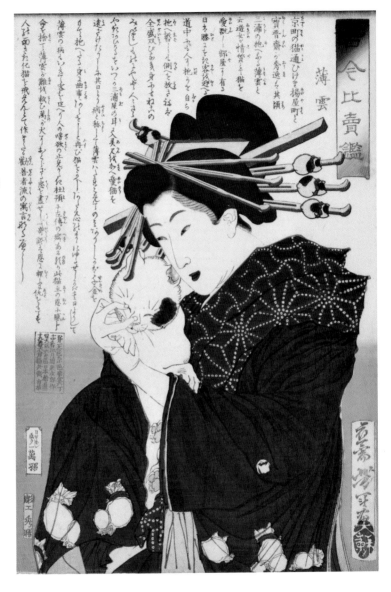

Tsukioka Yoshitoshi, 1839–1892. *Usugumo, from the series Mirror of Women Ancient and Modern, ca. 1875–76. Published by Yorozuya Magobei. Woodblock print, ink and color on paper, approx. 14⅝ x 10 in (37.2 x 25.5 cm). Image courtesy of Scholten Japanese Art.*

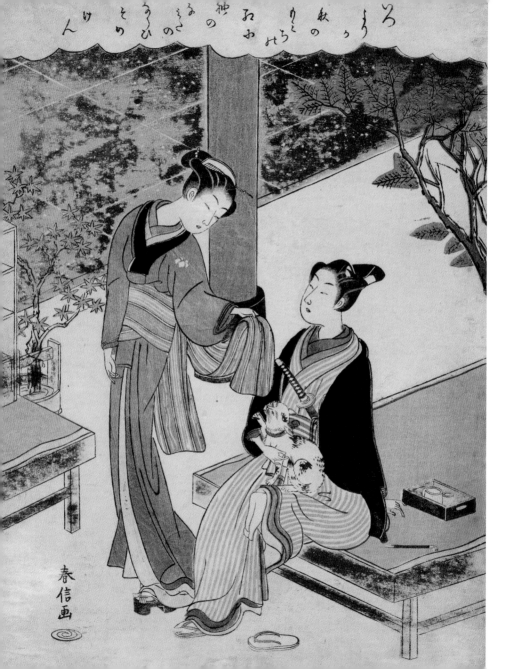

snake that had been lurking in the privy, killing it, and saving Usugumo. Overwhelmed with grief and guilt, the brothel residents gave the cat a solemn Buddhist funeral at Dōtetsuji temple in Asakasa, and interred its remains under a small mound on the grounds. According to one anthologist, the custom of prostitutes keeping cats originates with this incident.

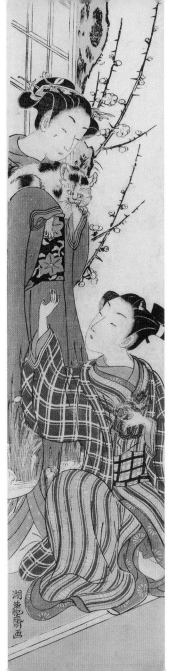

KITTY COQUETRY

In two images by Harunobu and Koryūsai, the playful kitten appears as a symbol of a woman's charms, wiles, and sexuality, as well as of the male subject's piqued—or tormented—desire. Harunobu's print of the beautiful waitress Osen teasing a cat nestled in the lap of a handsome young customer with the sleeve of her robe, would likely have brought the story of the princess's playful kitten, the flapping blind, and Kashiwagi's fatal attraction to the minds of contemporary viewers. Osen was a famed beauty employed at the Kagiya teahouse at the Kasamori shrine in Edo, and a favorite subject of Harunobu. He does not name her here, but she can be identified by the crest on her kimono.

LEFT **Suzuki Harunobu, 1725–1770.** *Osen of the Kagiya and a Young Man with a Cat, ca. 1769. Woodblock print, ink and color on paper, 11⅛ x 8⅜ in (28.2 x 21.3 cm). Fine Arts Museums of San Francisco, Katherine Ball Collection.*

RIGHT **Isoda Koryūsai, 1735–1790.** *Cat and Mouse, ca. 1780. Woodblock print, ink and color on paper, 27¹¹⁄₁₆ x 4⅞ in (68.8 x 12.4 cm). Minneapolis Institute of Art, Bequest of Louis W. Hill, Jr.*

Nudes and Cats

Drawing from ukiyo-e and European modernist painting, images featuring a nude or semi-nude woman with a cat—especially a black cat—emerged as a popular and provocative theme in Japanese prints in the early 20th century. The nude itself was a relatively new and risqué subject for artists at that time, there being no respected tradition of the nude equivalent to that in the West. Until the early 1920s, paintings and sculptures of naked women were sometimes covered up in public exhibitions and censored in print.

As with imagery related to Kashiwagi episode of *The Tale of Genji* and Sukenobu's painting introduced above, the cat can both stand in for the visually

absent but implied male subject and female sexuality. The theme draws parallels between the beauty, softness, and sensuality of the feline and female bodies, and alludes to parts of the female anatomy that are otherwise left to the viewer's imagination. The addition of the feline brings them into the realm of *abuna-e* or "dangerous pictures" that skirt the line between the titillating and the explicitly erotic.

The composition of Capelari's print plays on visibility, concealment, absence, and suggestion. A young woman with messy hair and a red underskirt or *koshimaki* crouches behind a folding screen, presumably erected around a futon to afford some privacy to the activities taking place there. Her

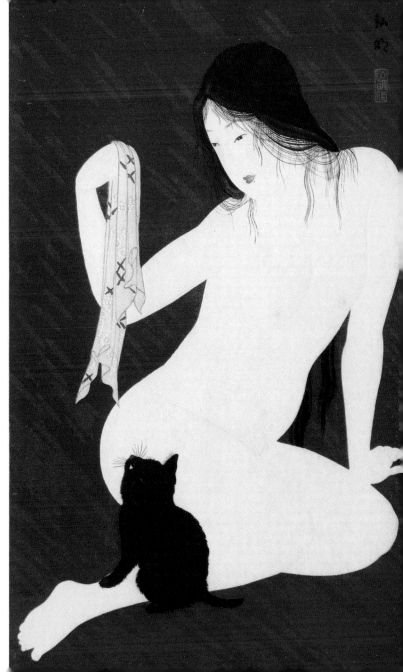

LEFT **Friedrich (Fritz) Capelari, 1884–1950.** *Nude Woman Holding a Black Cat, 1915. Published by Watanabe Shōzaburō. Woodblock print, ink and color on paper, 9¼ x 13 in (23.5 x 33 cm). Image courtesy of Scholten Japanese Art.*

RIGHT **Takahashi Hiroaki (Shōtei), 1871–1945.** *Nude Playing with Cat, ca. 1927–30. Published by Fusui Gabo. Woodblock print, ink and color on paper with embossing, 17⅛ x 10¾ in (43.5 x 27.2 cm). Image courtesy of Scholten Japanese Art.*

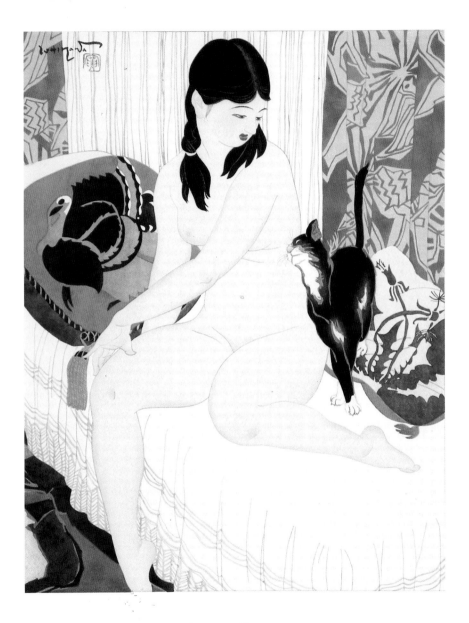

Chapter Three

patient stealth is such that a large fluffy cat has settled in her lap. Capelari, an Austrian watercolorist who had been living in Asia since 1911, was the first painter to be successfully recruited by publisher Watanabe Shōzaburō (1885–1962) to create designs for what he would call *shin hanga* or "new prints"— woodblock prints that interpreted the themes and techniques of ukiyo-e with a contemporary sensibility. Because of the commercial taint of woodblock printing, Watanabe initially struggled to recruit Japanese artists. The partnership yielded twelve prints in 1915, and two more in 1918 and 1920.

Shōtei escalated the raciness of the theme with his print of a completely naked woman with cascading locks of hair teasing a black kitten with an indigo dyed handtowel. The animal's fur and the outlines of the woman's body are embossed using *karazuri*. This technique, explained earlier, gives the suggestion of three-dimensional volume to an otherwise flat composition. The realistically drawn cat contrasts with the stylized depiction of the woman's body and face, which recalls images of women in ukiyo-e produced a century earlier. The audaciously erotic theme and the dramatic palette of black, ivory, and luscious red make this one of the most arresting designs of the era.

LEFT **Ishikawa Toraji, 1875–1964.** *Black Cat, from the series Ten Types of Female Nudes, 1935. Published by the artist. Woodblock print, ink and color on paper with mica, 19¼ x 14⅞ in (48.9 x 37.8 cm). Image courtesy of Scholten Japanese Art.*

ABOVE RIGHT **Ishikawa Toraji, 1875–1964.** *Bored, from the series Ten Types of Female Nudes, ca. 1934–35. Published by the artist. Woodblock print, ink and color on paper with mica, 14¾ x 19 in (37.5 x 48.3 cm). Image courtesy of Scholten Japanese Art.*

The two artworks by Ishikawa Toraji come from an ambitious, taboo-breaking series of nude women, perhaps inspired by the languid ladies playing idly with their cats in the monochrome prints of Felix Valloton. The subjects' Western-style haircuts, careless dishabille, and fashionably bohemian surroundings are characteristic of the "modern girl" or *moga*, Japan's version of the flapper in the 1920s and 30s. The *moga* was known for dancing, drinking, and smoking, and enjoying unprecedented sexual and financial freedoms. As such, she challenged traditional values and notions of femininity. Naturally, the *moga* was largely an invention of popular media, reflecting the fears and fantasies of a society in flux. While overtly European and modernist in style, the theme of the woman finding pleasure in the company of her cat, herself, and her books (incidentally, Toraji's modern girl in *Bored* is humorously mirrored by the face of the Edo-period beauty on the page open before her) has ample precedence in Japanese art.

The Feline Muse

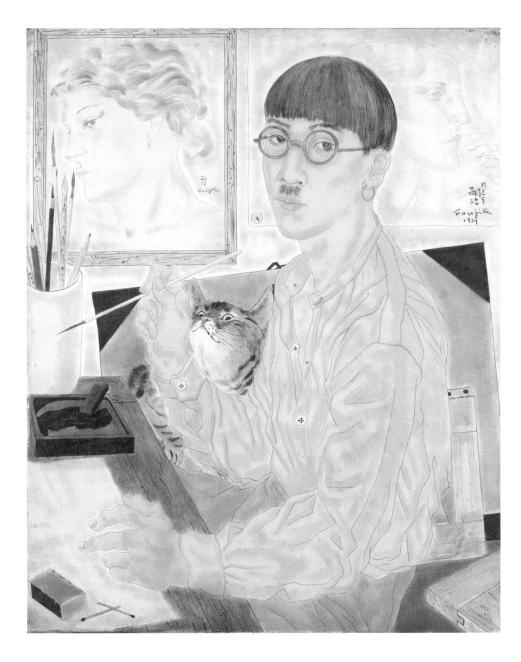

Cats in the Studio

Lithe and handsome, the feline figure is an ideal subject for an artist to explore the abstract values of fluid lines and organic forms, while its glossy fur and markings lend themselves splendidly to the interplay of textures and materials. Cats' expressive range presents an inviting challenge to the patient and sensitive artist, while their air of mystery and insouciance makes them endlessly alluring. Their small size, affability, and ability to sit still for long periods of time make them convenient models.

This chapter features artworks that seek to articulate the cat-ness of cats. Drawn from a range of media across the 19th and 20th centuries, these prints, paintings, and sculptures represent a broad range of approaches to the feline form—abbreviated line drawings, crisp and detailed formal realism, expressive simplification, fragmentation, and abstraction. Whether or not the artist is interested in faithfully reproducing the physical form of the cat, each image eloquently conveys a distinctive feline quality.

The foremost cat man of ukiyo-e is Utagawa Kuniyoshi (1798–1861), whose images are scattered throughout this volume. Following the successful release of his Suikoden series (ca. 1827–30), which established him at the forefront of the genre of warrior prints, Kuniyoshi began indulging his affection for the creatures by designing prints featuring cats—interspecies friendships, heroic mousers, riotous

Léonard Tsuguharu Foujita, 1886–1968. *Self-Portrait, 1929. Oil on canvas, 24 x 19¾ in (61 x 50.2 cm). The National Museum of Modern Art, Tokyo © Foundation Foujita/ADAGP.*

anthropomorphic moggies, and supernatural felines. His many images of cats capture feline form, mood, and manners with sensitivity and wit.

According to Kuniyoshi's contemporary, the writer Sekine Yasunori, there were always five or six pet cats in his home atelier, and he often had a kitten in each pocket, which served as his constant models and muses. He had a Buddhist altar installed in his home for memorializing his departed pets. In an anecdote attributed to his student Yoshimune, when one of his beloved cats died, he was directed to deliver the animal's remains, together with money for memorial rites, to a nearby temple. The faithless Yoshimune tossed the dead cat in the river and squandered the money on a night on the town.

The artist Kawanabe Kyōsai depicted himself receiving instruction from Kuniyoshi as a child aged between seven and nine years. Kuniyoshi, depicted at the center of the right page, seems unfazed by the chaos erupting in the studio around them (page 77). A cat tucked into the front of the master's kimono bats paws with another sprawled across Kuniyo-

shi's desk, egged on by a student. Three more cats, including a playful kitten, are on the floor below. The woman behind is Kuniyoshi's student Yoshitama.

Like his teacher, Kyōsai was a prolific artist and influential teacher. Through his friendships with prominent visitors to Japan such as English architect Josiah Conder and participation in international expositions, he established a high profile in the West.

Woodblock printed *edehon*, or painting manuals, were produced by most schools of painting in the 18th and 19th centuries. They could be used as training texts for professional and hobby painters, and were also enjoyed by non-artists. For established artists like Hokusai and Hiroshige, the *edehon* was a potentially lucrative undertaking, and offered the possibility of disseminating their styles beyond their teaching ateliers.

Hokusai's *One-Brushstroke Picture Book* (*Ippitsu gafu*, 1824) is a miscellany of line drawings executed with an economy of brushstrokes. Among figures, birds, other animals, Hokusai included three cats (page 79). Their compact, rounded forms were ideally suited to the constraints of the exercise. Hokusai's models demonstrate playfully how a single fluid line can materialize the shell-like forms of two pointed ears, an arced spine tightening into a tail, hindleg, or a knotted collar. One or two extra strokes become closed eyes.

In his *Picture Album of the Floating World*, Hiroshige included a variety of lifelike poses to inspire his pupils—crouching, pouncing, grooming, playing with string and *temari* (decorative balls made of colored thread), stretching, and napping (page 78).

ABOVE **Utagawa Kuniyoshi, 1798–1861.** *Drawing of a cat and kittens, 1840–1861. Drawing, ink on paper, 3¹¹⁄₁₆ x 9⁷⁄₁₆ in (9.4 x 24.0 cm). National Museum of Ethnology, Leiden, Rembrandt Association.*

Chapter Four

ABOVE **Utagawa Kuniyoshi, 1798–1861.** *Drawing of a cat with a red collar, 1840–1861. Drawing, ink and color on paper, 4¹⁷⁄₃₂ x 3¹¹⁄₃₂ in (11.5 x 8.5 cm). National Museum of Ethnology, Leiden, Rembrandt Association.*

RIGHT **Kawanabe Kyōsai, 1831–1889.** *Kyōsai's Account of Painting (Kyōsai gadan), 1887. Published by Iwamoto Shun. Volume 1 of a set of four woodblock printed books, ink and color on paper, approx. 9¹³⁄₁₆ x 7⅛ in (25 x 18 cm). Waseda University Library.*

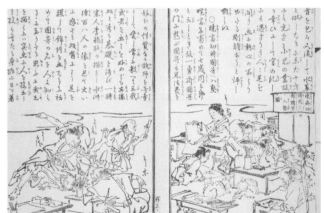

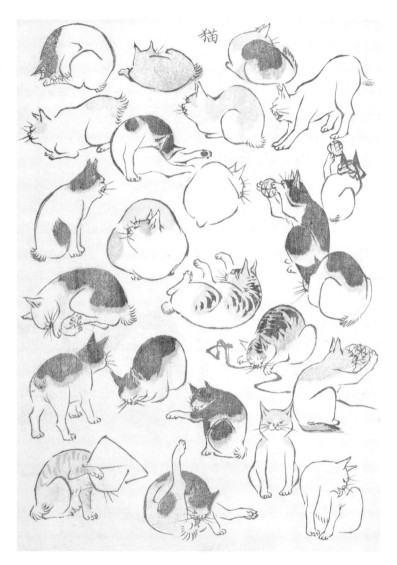

Utagawa Hiroshige, 1797–1858. *Picture Album of the Floating World (Ukiyo efu), ca. 1830. Published by Eirakuya Tōshirō et al. Volume 3 of a set of three woodblock printed books, ink and color on paper, 9¹⁄₁₆ x 6¼ in (23 x 15.9 cm). The Metropolitan Museum of Art, Mary and James G. Wallach Family Foundation Gift, 2013.*

Chapter Four

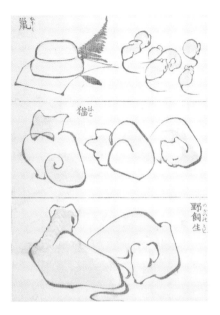

Hiroshige is less known as an artist of cats than his prolific contemporary Kuniyoshi, but his playfully rendered felines suggest a genuine affection for the animals—he reportedly had several as pets—and present an irresistible invitation to budding artists to put brush to paper.

I never look at men, only at women—they have, each one such marvelous possibilities of beauty. But unfortunately, most of them have not developed these possibilities because they have not learned the lessons cats can teach (…) Cats are never in a hurry, never angular. They move softly, gently, insinuatingly. Clever women live with cats… They study the animal's movements, habits and emotional reactions…
—Léonard Tsuguharu Foujita,
Milwaukee Journal, 1935

ABOVE **Katsushika Hokusai, 1760–1849.** *Transmitting the Spirit, Revealing Form of Things: Picture Album of Drawings at One Stroke, 1823.* Published by Eirakuya Tōshirō et al. Woodblock printed book, ink and color on paper, 9 x 6¼ in (22.8 x 15.8 cm). The Metropolitan Museum of Art, Purchase, Mary and James G. Wallach Foundation Gift.

RIGHT **Léonard Tsuguharu Foujita, 1886–1968.** *Sleeping Cat, 1947.* Pen and wash drawing, 2¹⁄₁₆ x 8⁷⁄₁₆ in (5.2 x 21.4 cm). Saint Louis Art Museum, Gift of J. Lionberger Davis, © Foundation Foujita/ADAGP.

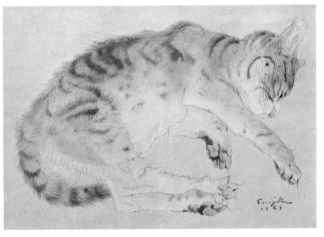

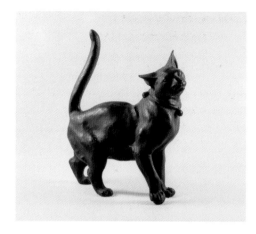

Like Kuniyoshi, the Japanese-French artist Léonard Foujita was an ardent cat lover. He took in scrappy strays off the streets of Montparnasse, and frequently depicted them as the main subject or as furry companions in portraits of his muses, and in self-portraits like that on page 74. He admired feline temperament and poise, the combination of wildness and domesticity they embodied—attributes he associated with women, his other passion. In the self-portrait, Foujita's tabby seems to demand to be included. Three years after this work was painted, his highly sought-after *Book of Cats*, containing twenty etchings, was published as a limited edition of five hundred copies in New York by Covici Friede, 1930.

Foujita studied Western-style painting at Tokyo School of Fine Arts (now Tokyo University of the Arts), graduating in 1910. In 1913, he moved to France. Cutting a flamboyant figure with his round glasses, blunt haircut, and chunky gold earring, Foujita adopted a Francized name and rapidly be-

came a central personage of the Ecole de Paris. While living in Europe, he developed a distinctive modernist style combining delicate, calligraphic linework and reduced palette typical of East Asian-style ink painting, with subtle modelling and compositional devices learned from his training in oils. He returned to Japan during the war, where he supported Japan's imperial expansion as a war artist and through an official appointment as a cultural attaché. In 1950, he returned permanently to France, adopting French citizenship and converting to Catholicism.

Foujita's peer, Asakura Fumio, is one of Tokyo's most beloved sculptors. He initially aspired to study haiku, but his plans were thwarted by the death of his intended teacher, Masaoka Shiki (1867–1902). His older brother, the sculptor Watanabe Osao (1974–1952), encouraged him to follow him into an artistic career. At that time, artists were needed to design the monuments celebrating modern Japan's achievements and give visual expression to its emerging identity that were mushrooming in public spaces all over Japan. Thus, Asakura shifted course, and succeeded in entering the sculpture course at Tokyo School of Fine Arts the following year. While focusing on human figures, when he could not afford to pay models, he took his sketchbook to Ueno Zoo, just next door.

After graduating in 1907, he established his studio in the nearby Yanaka district. He participated to acclaim at government sponsored exhibitions and received important commissions, for which he created dignified, emotionally nuanced human figures. Working in clay or plaster, he developed a realistic, impressionistic style that recalls the work of the French sculptor August Rodin. As with Rodin, the expressive, even roughly modelled, forms and surfaces seem to hum with energy.

In his private life, Asakura was an ailurophile, and kept numerous cats as pets. Apparently more for personal enjoyment than for clients or public exhibition, Asakura also made many lifelike sculptures of cats. His time spent sketching zoo animals as a student perhaps trained his eye and hand to capture the vitality of a living creature that will hold a pose not an instant longer than it pleases. In the 1960s, plans began for an exhibition of one hundred of his cat sculptures, but he died before this project could come to fruition.

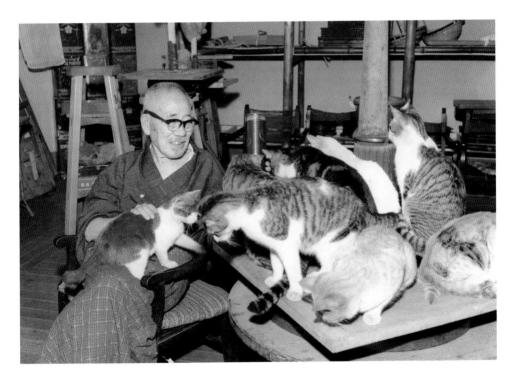

Feline Beauty

A cat twists to groom itself, her gleaming green eyes meeting those of the viewer. Her soft fur is realistically rendered in washes of ink and color, with individual follicles drawn with fine brushstrokes. The absence of background elements, the cat's dynamic pose, and her arresting gaze make this one of Takeuchi Seihō's most memorable works of art.

Seihō encountered this beautiful cat, which

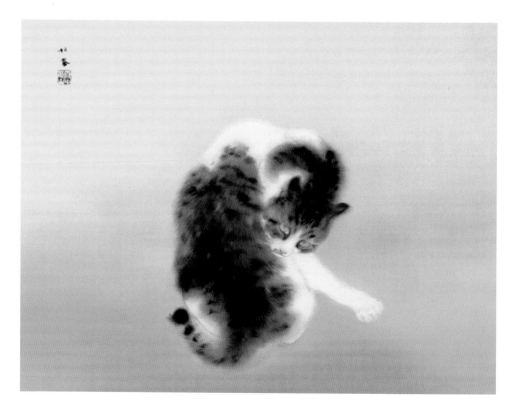

belonged to a greengrocer, while traveling in Numazu. She reminded him of a painting by the Song dynasty (960–1279) emperor Huizong, and he immediately felt compelled to create his own feline portrait. He traded a painting for the cat and took her back to his Kyoto atelier, where he studied, sketched, and photographed her. The completed work unifies Western-style formal realism based on drawing from life with the decorative sensibilities emphasized in traditional Japanese painting.

Seihō's celebrated tabby was preceded by Hishida Shunsō's famous painting of a fuzzy black cat perched on the trunk of an oak tree. The cat's angled ears, piercing eyes, and splayed paws, create the sense of an instant frozen in time, before the creature scampers off. The velvety blackness of the cat provides a striking accent amid a harmony of gold and gray tones.

Shunsō was a student of Okakura Tenshin, and a pioneer of *nihonga*, neo-traditional "Japanese style painting." At the time he painted this artwork, Shunsō was suffering eye problems. Nonetheless, he is said to have completed this painting in just a week. The work was accepted into the fourth Ministry of Education Painting Exhibition in 1910. Shunsō died the following year, just days before his 37th birthday.

LEFT **Takeuchi Seihō, 1864–1942.** *Tabby Cat, 1924. Painting mounted as framed panel, ink and color on silk, 40 x 32¼ in (101.6 x 81.9 cm). Yamatane Museum of Art, Important Cultural Property.*

RIGHT **Hishida Shunsō, 1874–1911.** *Black Cat, 1910. Hanging scroll, ink, color, and gold on silk, 59⅛ x 20⅟₁₆ in (150.1 x 51 cm). Eisei Bunko, Important Cultural Property.*

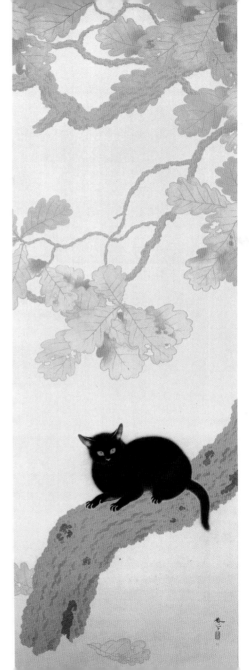

LEFT **Hashimoto Gahō, 1835–1908.** *Cat in Bamboo Grove, 1896. Hanging scroll, ink and color on silk, 48⅛₆ x 19¹⁵⁄₁₆ in (122.1 x 50.6 cm). Tokyo National Museum.*

RIGHT **Shoda Kōhō, 1871 or 1877–1946.** *Black Cat at Night, from the series "Japanese Scenes on 'Tanzaku' ", ca. 1920. Published by Hasegawa and Nishinomiya. Woodblock print, ink and color on paper, 13⁷⁄₁₆ x 3¼ in (34.13 x 8.1 cm). Los Angeles County Museum of Art, Gift of Chuck Bowdlear, Ph.D., and John Borozan, M.A.*

Chapter Four

"Cats—*Cats should be completely black except
for the belly, which should be very white.*"
—Sei Shōnagon, *The Pillow Book* (1002),
trans. Meredith McKinney (2007)

In the green shadows
the eyes of a black cat
flashes of gold
—Kawabata Bōsha, 1897–1941

Takahashi Hiroaki (Shōtei), 1871–1945.
*Black Cat, ca. 1929. Published by Fusui Gabo.
Woodblock print, ink and color on paper, 10⅝ x
15⅜ in (26.9 x 39.2 cm). Image courtesy of
Scholten Japanese Art.*

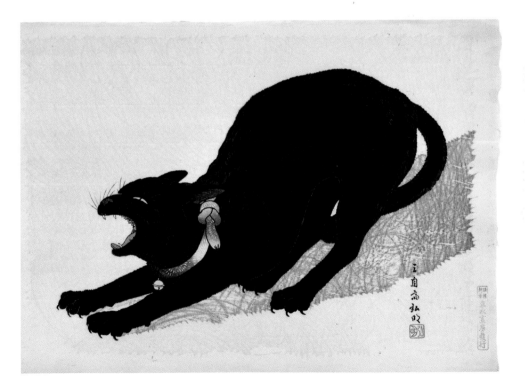

Modernist Cats

The playful design of this pair of bookends deftly captures the figure of a stretching feline. Blending natural, organic forms with the geometry of the industrial age, the artist interpreted the cat's supple body as an elegantly faceted *objet*. Sharp linear ridges lead the viewer' eye from its chunky front paws upward along the s-bend curve of its spine to the jaunty curl of its tail.

Osaka-born Neya Chūroku studied metal casting at Tokyo School of Fine Arts, graduating in 1926. He participated in the exhibition of the Imperial Art Academy, where he was awarded a special prize (*tokusen*) in 1933, as well as several artist-run collectives. He was invited to participate at the Chicago World Fair, also known as the Century of Progress International Exposition, in 1933.

Although highly stylized and simplified, Kumagai Morikazu's cat paintings are expressive and carefully observed. Reduced to masses of flat, contrasting, earthy colors bordered with red outlines, they nonetheless convey the cattiness of his subjects. Kumagai produced dozens of paintings of cats in oils and ink in the 1950s and 60s. Following a stroke in 1956, he restricted his movements to his small garden in Tokyo's Ikebukuro Montparnasse arts quarter, and painted the small plant and animal life—camellia blossoms, frogs, dandelions, butterflies, snails, and his cats—that dwelt there.

Born into a prosperous family in the mountainous Kiso region, Kumagai trained in Western-style oil painting at Tokyo School of Fine Arts. After graduating in 1904, during the Russo-Japanese War

Neya Chūroku, 1897–1987.
Bookends in the Form of Cats, ca. 1930s. Bronze, 5¾ x 7⅛ x 3⅞ in (14.6 x 18.1 x 9.8 cm). Collection of Robert and Mary Levenson.

ABOVE **Kumagai Morikazu, 1880–1977.** *Cat*, 1965. Painting, oil on wood, 9½ x 13⅛ in (24.1 x 33.3 cm). Aichi Prefectural Museum of Art, Kimura Teizo Collection.

RIGHT **Kumagai Morikazu, 1880–1977.** *Cat*, 1963. Painting, oil on canvas, 16¾₁₆ x 12¹⁵⁄₁₆ in (41 x 32 cm). Aichi Prefectural Museum of Art, Kimura Teizo Collection.

(1904–05), he was sent to the island of Sakhalin to create topographical images.

As a young artist, he participated in the government sponsored salon in 1909 and the Nikakai, Japan's version of the Salon des Refusés, from 1915, but struggled to support his growing family though painting. His did not have his first solo exhibitions until 1938. In 1947, he was a founding member of the progressive Nikikai society, but terminated his membership in 1951. In 1967 and 1972, he was offered the Order of Culture, but declined it on both occasions.

Onchi Kōshirō's minimalist prints distil the feline figure, with its lithe form and fluid movement, down to its essence. Onchi was a pioneer of Japanese modernism and a central figure of the *sōsaku hanga* or creative print movement. While studying sculp-

BELOW LEFT **Onchi Kōshirō, 1891–1955.** *Image No. 7: Black Cat (b), 1952. Paperblock print, ink and color on paper. 18 x 14³⁄₁₆ in (45.5 x 36 cm). Honolulu Museum of Art, Gift of James A. Michener, 1991.*

BELOW RIGHT **Onchi Kōshirō, 1891–1955.** *Image No. 7: Black Cat (c), 1952. Paperblock print, ink and color on paper, 17³⁄₄ x 14³⁄₁₆ in (45.1 x 36 cm). Honolulu Museum of Art, Gift of James A. Michener, 1991.*

ture at Tokyo School of Fine Arts, he founded the seminal poetry and print magazine *Tsukuhae* with his classmates Shizuo Fujimori (1891–1943) and Tanaka Kyōkichi (1892–1915). In 1915, the magazine published Onchi's print *Bright Hours*, which is credited as being Japan's first purely abstract work of art.

Onchi was not only a pioneer of modernism, but also a mentor to younger artists in his circle, including Sekino Jun'ichirō and Saitō Kiyoshi who are represented in this book. After the war, several artists and art lovers residing in Japan as part of the Allied Occupation joined their ranks, and the group, meeting in Onchi's home, became a site of cultural exchange and friendship between former enemies.

Among Onchi's mentees was Inagaki Tomoo. In his print *Cat Walking*, looping lines describe the fluid, purposeful gait of a bob-tailed cat. The bold geometry of *Cat Making Up*, with repeated curves and diagonals, suggest the efficient gesture of a cat's forepaw as it washes its face and behind its ears. This small watercolor is a rare study for a design that Inagaki Tomoo printed in 1955.

Inagaki began making prints of cats around 1951, and by about 1961 was entirely devoted to this subject. When prints of cats by Inagaki and Saitō Kiyoshi were exhibited at The John and Mable Ringling Museum of Art in 1957, they delighted American audiences and were hailed in the *Sarasota Herald Tribune* as "masterpieces of the suggestive."

Cats are a key theme in the work of Saitō, one of Japan's most internationally renowned printmakers. His dozens of prints of cats in various attitudes— wily, languid, quizzical, haughty, affectionate— reveal the artist's sensitive eye and playful sense of humor. However, he disclosed to an interviewer that

Inagaki Tomoo, 1902–1980. *Study for Cat Making Up, ca. 1955. Watercolor on paper, 6⅜ x 4⁹⁄₁₆ in (16.2 x 11.6 cm). John Fiorillo Collection.*

ABOVE **Inagaki Tomoo, 1902–1980.**
*Cat Walking, 1953. Woodblock print, ink
and color on paper, 14⅜ x 22¼ in (36.5 x
56.5 cm). The John and Mable Ringling
Museum of Art, Gift of Mr. and Mrs. Karl A.
Bickel, 1961.*

RIGHT **Saitō Kiyoshi, 1907–1997.**
*Steady Gaze (Cat), 1948. Woodblock print,
ink and color on paper, 31⅛ x 17¹¹⁄₁₆ in
(79 x 45 cm). Collection of Charles and
Robyn Citrin.*

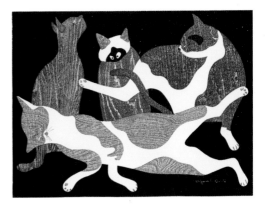

RIGHT **Saitō Kiyoshi, 1907–1997.** *Cats, 1973.*
Woodblock print, ink and color on paper, 21⅝ x 26 in (55 x
66 cm). The John & Mable Ringling Museum of Art, Gift of
Charles and Robyn Citrin.

BELOW **Saitō Kiyoshi, 1907–1997.** *Suspicion, 1973.*
Woodblock print, ink and color on paper, 21⅝ x 32 in (55 x
81.3 cm). The John & Mable Ringling Museum of Art, Gift
of Charles and Robyn Citrin.

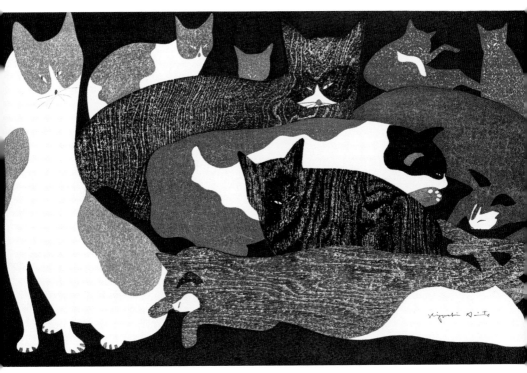

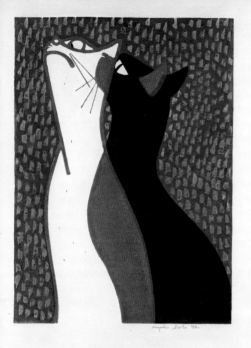

Saitō adopted this technique from the prints of modernist artists that he admired, such as Paul Gauguin (French, 1848–1903) and Edvard Munch (Norwegian, 1863–1944), who had themselves learned it from Japanese print makers, like Hiroshige.

Time magazine reproduced *Steady Gaze (Cat)* in its September 1951 issue—just a few weeks after Saitō was awarded the Japan Prize at the São Paulo Biennial in Brazil. Saitō recalled that due to this level of publicity, "my gallery was swamped with orders for *Cat* from around the world. In no time at all, the print disappeared from Japan" (*Time*, Feb. 10, 1967).

Saitō lost no time in coming up with new feline designs to satisfy his expanding audience. Editions of up to 200 impressions indicate considerable demand for these prints. However, it was not only their charming subject matter that delighted the crowds—Saitō's cat prints were inventively conceived and executed. Fluid lines describe the grace of the feline figure, while lively textures animate the compositions. With just a few lines and marks, Saitō evokes indelibly feline moods and manners.

Saitō's affinity for *mokume-zuri* is given full play in a group of cat designs from the 1970s, inspired by the furry gang that congregated at the home of a friend. For these prints, he arranged multiple pieces of wood with contrasting grain patterns in different orientations to represent the animals' fur. These collage-like compositions have a sense of rhythm and tactility that makes them among the most visually compelling of Saitō's later works.

In two prints by Aoyama Masaji and Sekino Jun'ichirō, the silhouetted form of a lone feline disrupts the rhythmic pattern of rooftiles. Cats enjoy domestic comforts without being attached to them,

he didn't particularly like cats. He explained, "When you look at a cat, it takes on different forms. I draw them because I find that interesting" (see Fukushima Prefectural Museum of Art, *Munekata Shikō and Saitō Kiyoshi*, 2000).

Saitō's first major cat design was *Steady Gaze (Cat)* (1948), depicting an owlish feline with a disdainful gaze. Theophile-Alexandre Steinlen's (French, 1859–1923) famous 1896 poster for the Parisian nightclub Le Chat Noir was perhaps the inspiration for its flattened ears and cool stare. The background is printed with layers of red with gray *mokume-zuri*, or woodgrain printing, in which an impression is made from a piece of prominently grained wood.

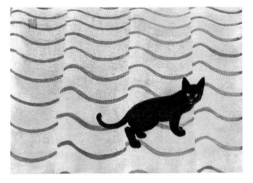

and pass freely between the home and the urban wilderness. Their independence, insouciance, and physical agility appears as a metaphor for modern bohemia, freedom from bourgeois concerns. They remind us humans of our earthbound existence, constrained by gravity, clumsy bodies, responsibilities, and social conventions.

Less well known than his contemporaries Sekino and Saitō, Aoyama Masaji created skilfully textured woodblock prints of cats, birds, and rural scenery. His preference for monochromatic designs perhaps follows from his training in traditional ink painting at Tokyo School of Fine Arts. He began making prints and became affiliated with the *sōsaku hanga* movement in the late 1920s, but also worked with commercial publishers.

The Cat's Kimono

Second only to cats themselves is a fabulous feline-themed outfit. These dashing heroines (and hero) of the floating world wear their ailurophilia on their sleeves.

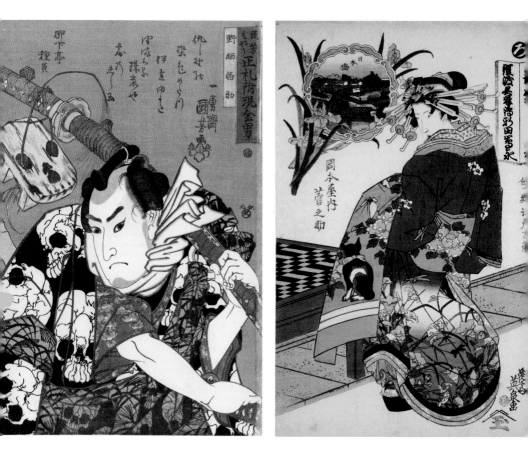

Chapter Four

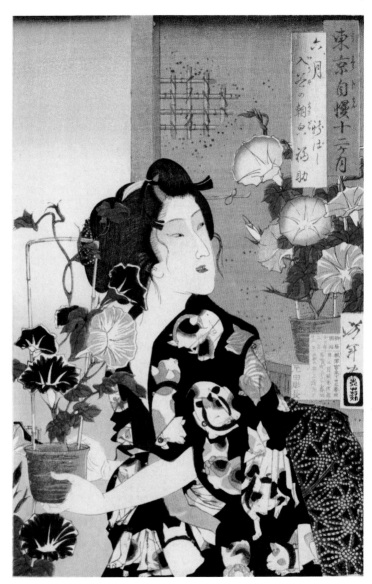

FAR LEFT **Utagawa Kuniyoshi, 1798–1861.** *Nozarashi Gosuke, from the series Men of Ready Money with True Labels Attached, Kuniyoshi Fashion, ca.1845. Published by Ibaya Kyubei. Woodblock print, ink and color on paper, 14⅝ x 9⅞ in (37.1 x 25.1 cm). Museum of Fine Arts, Boston, William Sturgis Bigelow Collection.*

LEFT **Keisai Eisen, 1790– 1848.** *Published by Moritaya Hanzō. The Syllable "Ro": Suganosuke of Okamotoya, from the series Courtesans for Compass Points in Edo, ca. 1829. Published by Moritaya Hanzō. Woodblock print, ink and color on paper, approx. 15⅜ x 10⁷⁄₁₆ in (39 x 26.5 cm). National Museum of Ethnology, Leiden.*

RIGHT **Tsukioka Yoshitoshi, 1839–1892.** *The Sixth Month: Fukusuke of Shimbashi with Morning Glories at Iriya, from the series Pride of Tokyo's Twelve Months, 1880. Published by Inoue Mohei. Woodblock print, ink and color on paper, approx. 15⅜ x 10⅝ in (39 x 27 cm). National Diet Library, Tokyo.*

Lucky Cats

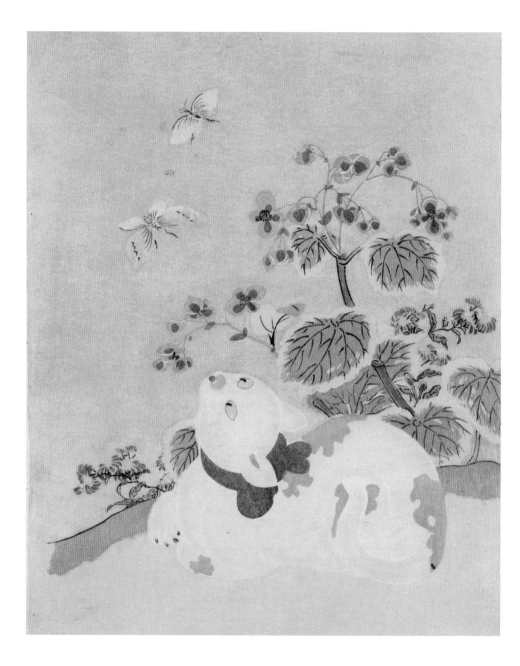

Auspicious Cats

In Western cultures, cats—especially black cats—have a complicated cultural history. In medieval Europe, cats were associated with Satan worship, possibly in relation to Greek myths of Galinthias being turned into a cat and serving as a priestess to Hecate, a goddess of the underworld. Pope Gregory IX's notorious papal bull of 1233, *Vox in Rama*, which characterized the *gattus niger* or black cat as the instruments and embodiment of the devil, resulted in purges and annual festivals in which thousands of cats were tortured and killed. Today, they remain popularly associated with misfortune, witches, and the occult. On the other hand, in parts of the British Isles, black cats were believed to bless a home with health and prosperity. Celtic folklore contains both sacred and malevolent cats.

LEFT **Attributed to Suzuki Harunobu, 1725–1770.** *Cat, Butterflies, and Begonias, ca. 1767. Woodblock print, ink and color on paper with gauffrage, 11⅛ x 8⁵⁄₁₆ in (28.3 x 21.1 cm). Rhode Island School of Design Museum, Gift of Mrs. John D. Rockefeller, Jr.*

RIGHT **Shibata Zeshin, 1807–1891.** *Bamboo, Umbrellas, a Cat and Butterflies, ca. 1877. Woodblock print, ink and color on paper, 7 x 9⅜ in (17.8 x 23.8 cm). Minneapolis Institute of Art, Gift of funds from Mr. and Mrs. Samuel H. Maslon.*

PREVIOUS SPREAD **Maneki neko figurines at Gōtokuji temple, Setagaya, Tokyo.**

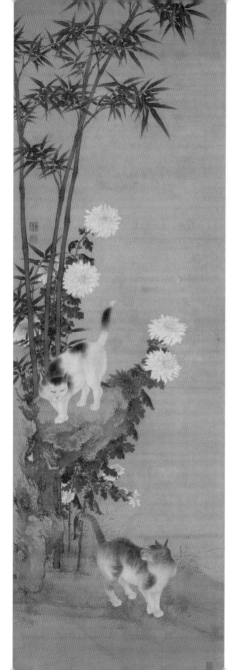

In Japan, cats are also connected with the supernatural, but the spiritual realm of *kami* being neither overwhelmingly positive or negative, or preoccupied with notions of human sin, there is no particular connection between cats and bad luck. In art and visual culture, both indigenous to Japan and adapted from China, cats are often depicted as auspicious creatures.

As well as making attractive and whimsical decorative subjects, images of cats could communicate hidden messages. The word for cat in Chinese, *māo*, is a homophone for the word for "eighty years of age." In Chinese court painting of China's Ming (1368–1644) and Qing dynasties (1644–1911), cats were often paired with butterflies, or *dié* in Chinese, which sounds like the word for "seventy years of age." Combined with other auspicious motifs such as peonies, bamboo, and chrysanthemums, a painting of cats could convey wishes for a long, prosperous, and honorable life.

The Chinese painter Shen Nanpin traveled to the port city of Nagasaki at the invitation of a Japanese official in 1731. During the two years he remained there, he instructed a large number of Japanese students in Chinese painting techniques and themes, with an emphasis on the realistic depiction of flowers and animals, meticulous detail, and the use of jewel-like colors. Nanpin's followers became known as the Nagasaki school of painting. These two paintings, created during Nanpin's sojourn in Japan, are filled with auspicious symbols.

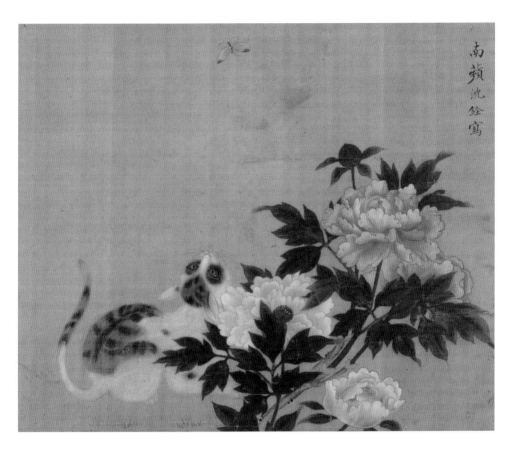

OPPOSITE **Shin Sen (Ch. Shen Quan, also known as Shin Nanpin; 1682–after 1758).** *Cats by Bamboo and Chrysanthemums, ca. 1732. Hanging scroll, ink and color on paper, 57⅝ x 18⅛ in/147 x 45.72 cm (image). Minneapolis Institute of Art, Mary Griggs Burke Collection, Gift of the Mary and Jackson Burke Foundation.*

ABOVE **Shin Sen (Ch. Shen Quan, also known as Shin Nanpin; 1682–after 1758).** *Cat and Butterfly among Peonies, ca. 1732. Hanging scroll, ink and color on silk, 15 x 20¼ in/38.1 x 51.12 cm (image). Minneapolis Institute of Art, Mary Griggs Burke Collection, Gift of the Mary and Jackson Burke Foundation.*

Maneki Neko

Japan has its own indigenous tradition of lucky cats. Step into virtually any kind of Japanese—and increasingly, non-Japanese—small business, and you are likely to be greeted by a model of a seated feline, one chubby paw raised to whisker-level. These *maneki neko*, or "beckoning cats," are a type of *engimono* or "lucky thing" that promises to usher in good fortune, customers, and financial success. Ranging from small figurines to larger-than-life-size statues, *maneki neko* are typically made from porcelain, plaster, papier-mâché, metal, or plastic.

There are numerous origin myths for this friendly mascot, and several temples and shrines across Japan claim to be its birthplace. One story connects the *maneki neko* to the story of Usugumo's cat saving her from a demonic snake introduced earlier. To comfort Usugumo for the loss of her heroic pet, a customer made a model of her cat, raising its paw in warning. Others hold that the cat's paw is raised to wash behind its ears, in a gesture said to indicate that visitors are coming, much like a cat washing behind its ears is a harbinger of rain in the West.

According to another tale, in 1633, Ii Naotaka (1590–1659), the lord of Hikone domain, took shelter under a large tree outside a rundown temple during a storm. While waiting for the tempest to pass, he noticed a white cat raising its paw in a beckoning gesture from the temple. Obediently, he hurried over

RIGHT **Ceramic *maneki neko*, 1880.** *21 x 9 x 9½ in (53.34 x 22.86 x 24.13 cm). Ceramic. Mingei International Museum, Gift of Billie L. Moffitt.*

FAR RIGHT **Ceramic *maneki neko*, 20th century.** *8½ x 5½ x 6 in (21.59 x 13.97 x 15.24 cm). Buff cotta clay. Mingei International Museum, Gift of Billie L. Moffitt.*

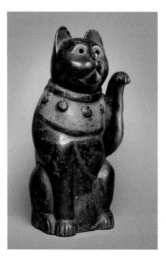
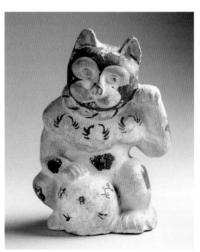

and not a moment later, a bolt of lightning struck the tree, blowing it to splinters. The cat led him to the priest, who impressed Naotaka with his wisdom. Naotaka decided that his family would sponsor the temple, thus restoring it to prosperity and ensuring it would flourish in the future. Following his death, it was renamed Gōtokuji after Naotaka's posthumous Buddhist name. The temple is located in Setagaya ward, in the western suburbs of Tokyo, and is famous today for its thousands of *maneki neko* figurines.

The oldest known prototype of the *maneki neko* is the *marushime no neko*, a type of low-fired earthenware figurine, called *tsuchi ningyō*, made in the Imado district of the city of Edo, corresponding to present-day Asakusa. Throughout the Edo and early Meiji periods, the kilns of Imado produced everyday things such as rooftiles and kitchenware, and *tsuchi ningyō*, which often had talismanic functions.

ABOVE **Maneki neko for sale in Haymarket, Sydney, Australia.**

LEFT **Maneki neko greeting diners in Haymarket, Sydney, Australia.**

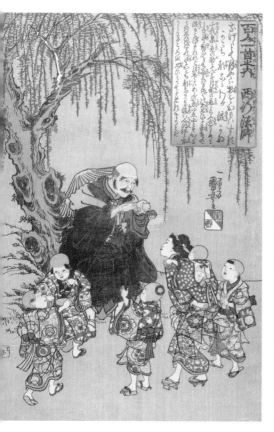

百々人一首六 西の海浦

ふげしく塚わたる
いるらと
あろうちか
晴ろさ

ABOVE **Utagawa Kuniyoshi, 1798–1861.** *Saigyō Hōshi, from the series One Hundred Poems from One Hundred Poets, ca. 1840–1842. Published by Ebisu. Woodblock print, ink and color on paper, approx. 15⅜ x 10⅝ in (39 x 27 cm). Harvard Art Museums/Arthur M. Sackler Museum, Gift of the Friends of Arthur B. Duel.*

OPPOSITE **Utagawa Hiroshige, 1797–1858.** *Flourishing Business in Balladtown, 1852. Published by Ibaya Senzaburō. Woodblock print, ink and color on paper, approx. 14⅜ x 9¹⁵⁄₁₆ in (36.6 x 25.3 cm). National Diet Library, Tokyo.*

The *marushime no neko* is usually painted white with black spots, simple facial features, a red collar, and sometimes the suggestion of a ruffled bib. It is sculpted to sit at right-angles to the front with its head turned to one side to face the beholder. This differs to later *maneki neko*, which usually sit and face squarely ahead. The word *marushime* derives from an expression of good tidings for prosperity and happiness. *Engimono* are typically regarded as ephemeral objects, intended to be discarded and replaced regularly. Because of this, and the low durability of *tsuchi ningyō*, few *marushime no neko* from the Edo period survive today.

According to an account in the *Bukyō Chronicle* (*Bukyō nenpyō*), compiled by Saitō Gesshin, the *marushime no neko* was born in 1852 when an elderly woman, stricken by poverty, was forced to part with her pet cat. The cat subsequently appeared to her in a dream and instructed her to make a clay figurine in its image, promising her good fortune if she did so. She did as she was told, and took the figurine to the gates of Imado shrine, where it promptly sold. She made another, which quickly sold, and then another, and soon the woman had a thriving business making what would come to be known as *marushime no neko*. Contemporaneous texts, such as the *Fujioka Diary* (*Fujioka nikki*), offer alternative versions of this story.

Hiroshige's print on the opposite page, published in 1852, is the earliest known record of the *marushime no neko*. In a bustling marketplace, street vendors sell bamboo shoots, handicrafts, and small cups of liquor. At top left, a male shopkeeper carefully offers a *marushime no neko* to a young woman.

But rather than a straightforward street scene, the artist cast characters from popular stories in the

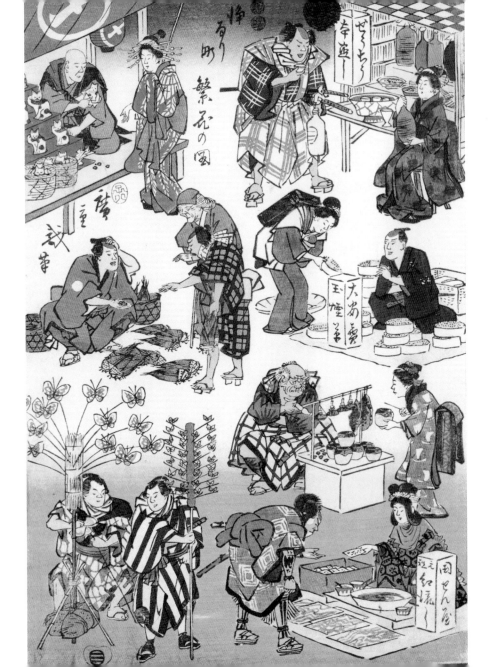

Hasegawa Sadanobu II, 1848–ca. 1940.
*Bandō Jūzaburō II, from the series Famed
Shadows of Actor's Dressing Rooms, 1884.
Published by Ono Toyojirō. Woodblock print, ink
and color on paper, 14⅜ x 9⅝ in (36.5 x 24.4
cm). Smart Museum of Art, The University of
Chicago, The Brooks McCormick Jr. Collection of
Japanese Prints.*

roles of the merchants and their customers. The shopkeeper, wearing monastic robes, is the warrior-turned itinerant poet and monk Saigyō (1118–90), while his young female customer, dressed as a courtesan, is his daughter. The interaction alludes to a story recorded on a stele at Tsurugaoka Hachi-mangu shrine in Kamakura. Minamoto Yoritomo (1147–99), the first shogun of the Kamakura military regime (1192–1333), invited Saigyō to his palace to discuss archery and military strategy. At the end of the evening, Yoritomo presented Saigyō with a small figure of a cat worked in silver as an expression of gratitude. But, caring little for material possessions, Saigyō immediately gave the cat to children he encountered on his way from the palace, as depicted in Kuniyoshi's print on page 104. When Saigō took up the tonsure, he relinquished not only his military career, but also his family, including a young daughter, who eventually became a nun. According to stories popularized on the kabuki stage, however, she became a courtesan in the Yoshiwara.

BACKSTAGE BLESSINGS

Perched on a *kamidana* overlooking the dressing room of actor Bandō Jūzaburō II is a small *maneki neko*. A *kamidana* or "spirit shelf" is a miniature Shinto altar installed in a home or business where offerings and prayers are made to the enshrined god or *kami*. Objects placed on this shelf include candlesticks, vases of flowers, and *engimono*, such as *maneki neko*, to bring good fortune.

Regional Maneki Neko Styles

From the late 19th century, regional towns began making their own distinct versions of *maneki neko*, using molds to facilitate mass production. Various types are introduced by Alan Pate in his book *Maneki Neko: Japan's Beckoning Cats from Talisman to Pop Icon* (2001). As at Imado, the Fushimi kilns in Kyoto had a long history producing talismanic *tsuchi ningyō*, in their case associated with Fushimi-Inari shrine. Possibly after observing the success of the *marushime no neko*, they expanded their repertoire to include lucky cats. Fushimi *maneki neko* are hand painted with white bodies, but are more delicately molded and finely decorated than the Imado prototypes, making them a degree or two more realistic. They have markings of black, gray and/or brown, approximating the *mike* or tricolor pelt of a calico cat. The most significant innovation of the Fushimi artisans, however, was to sculpt the cats such that they sit squarely upright, facing ahead, which became the standard pose for *maneki neko*.

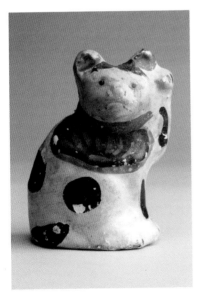

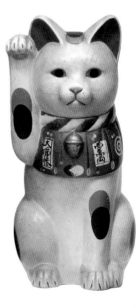

LEFT **Imado style composite *maneki neko*, ca. 1890.** *Gofun/sawdust, 4¼ x 2⅞ x 2 in (10.8 x 7.3 x 5.08 cm). Mingei International Museum, Gift of Billie L. Moffitt.*

RIGHT **Fushimi style *maneki neko*, 20th century.** *Clay, pigment, 13 x 5½ x 5½ in (33.02 x 13.97 x 13.97 cm). Mingei International Museum, Gift of Billie L. Moffitt Gift of Billie L. Moffitt.*

RIGHT **Mikawa style** *maneki neko*, **ca. 1870–1890.** *Low fired and hand painted clay, 8¹⁵⁄₁₆ x 6 x 5 in (22.5 x 15.25 x 12.7 cm). Image courtesy of Kagedo Japanese Art.*

FAR RIGHT **Seto style** *maneki neko*, **early 20th century.** *Porcelain with polychrome enamels, 8¼ x 5 x 5 in (20.96 x 12.7 x 12.7 cm). Image courtesy of Guillermina Emy LaFever.*

OPPOSITE **Tokoname style** *maneki neko* **in Sarasota, Florida, USA.**

Seto, one of Japan's so-called "six ancient kilns," began producing *maneki neko* made from porcelain, a denser, more durable material than earthenware. Like the Fushimi-style cats, Seto *maneki neko* tend to be slender and upright and are often equipped with elaborately molded ruffled bibs as well as the customary collar and bell.

Plump and appealing, the *maneki neko* produced in kilns in the Mikawa region around Nagoya in central Japan tend to have widely set haunches and ears that point directly ahead. Their earthenware bodies are glazed or hand-painted with similar markings to their Fushimi and Seto cousins. They are usually depicted with just a simple collar and bell, molded in relief and painted red.

The most familiar type today—a cartoonishly rotund white cat with black and brown spots, an oversized head set with wide eyes, clutching a gold coin in one chubby paw—is a seminal work of mid-century *kawaii* kitsch. The design dates to 1950 when it was produced by the Baigetsu Tomimoto Ningyōen factory in Tokoname, another of Japan's "six ancient kilns." A marketing campaign during the postwar economic boom placed the Tokoname style *maneki neko* in businesses and homes nationwide and beyond. Imitations of this type are manufactured domestically and abroad.

Although closely associated with urban businesses, in rural areas, *maneki neko* are said to have been displayed to appeal for good harvests. According to the Tomimoto factory, a raised right paw invites money, while a raised left paw invites people. Brightly colored versions marketed today promise personal safety, and success in love and school examinations.

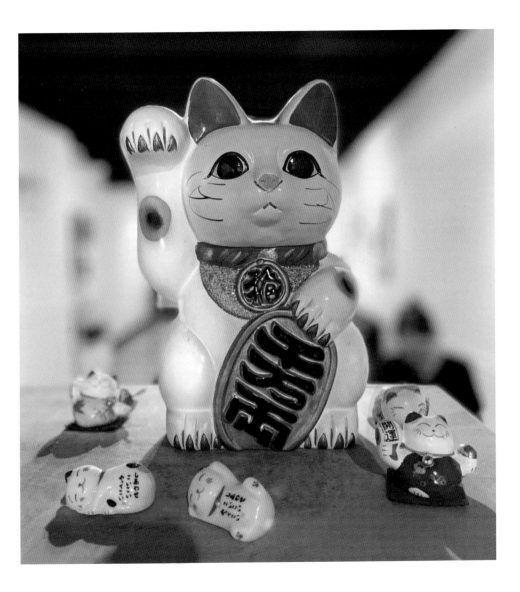

LUCKY CATS

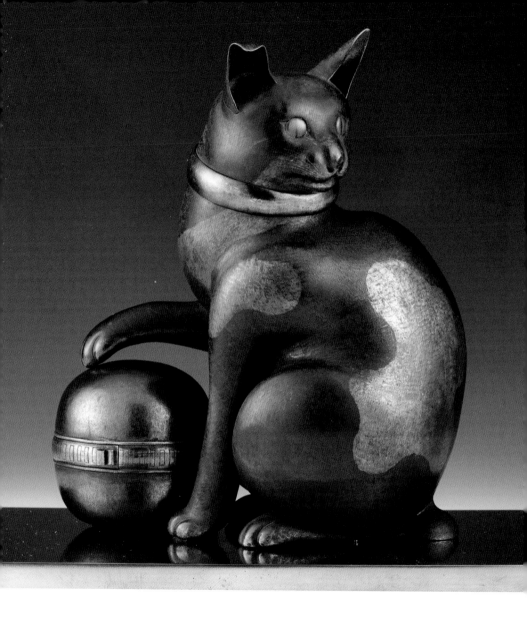

Chapter Five

Cat Okimono with Compass

This highly unusual *okimono*, or sculptural orna-ment, takes the form of a bright-eyed calico cat resting its paw lightly on a large Shinto shrine bell. As the forefoot is not raised, the cat does not quite meet the definition of a *maneki neko*, but it asserts an auspicious presence of its own.

Shinto bells like the one shown here come in a range of sizes—small ones, called *suzu*, attached to handheld ritual objects, while larger ones called *kane*, are hung at the entrance to shrines. Ringing them summons the gods, invoking their power and protection. They are not dissimilar to the bells that jingle from cats' collars, heralding their numinous presence with each step.

The bell in this piece opens sideways to reveal a compass inside. Is the cat the asserting its mastery over the realm? Might a capricious swipe of its paw set the earth spinning off its axis? The sculpture perhaps belonged to a purveyor of fine mechanical devices or scientific instruments, such as compasses, lenses, and timepieces. Cats are associated with time and measurement because their sensitive pupils contract and dilate in response to the light. During the Imjin War (1592–1598), during which Japan launched two invasions of Korea, the warlord Toyotomi Hideyoshi directed his general Shimazu Yoshihiro (1535–1619) to take seven cats on his expedition—reportedly to help his troops to coor-dinate their movements. Of the seven felines, two returned to Japan alive and were deified at a shrine on the family's estate, Senganen, in Kagoshima.

Cat okimono with compass, 18th century–early 19th century. *Cast and incised bronze. Cast, cold-chiseled and gilt bronze with inlaid glass eyes; the compass of cast, cold-chiseled and gilt bronze with a glass cover, 8 x 6³⁄₁₀ x 4³⁄₁₀ in (21 x 16 x 10.9 cm). Image courtesy of Kagedo Japanese Art.*

Mischief and Mayhem: Monster Moggies

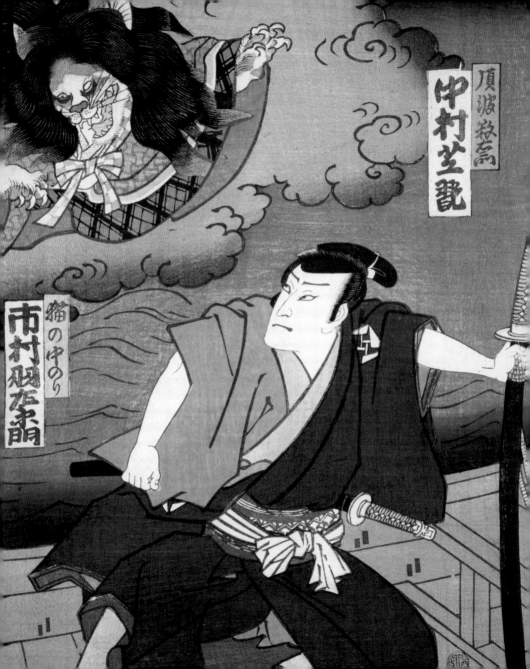

頂波松高
中村芝翫

猫の中のり
市村羽左衛門

Supernatural Cats

Notoriously inscrutable among domestic animals, cats can flip between aloofness, tranquility, and frenzied activity in an instant. Their glorious form and soft pelt conceal needle-sharp claws and teeth. Formidable predators, they move as silently as smoke. When threatened, they can transform into hissing, spitting, puffy-tailed, crab-walking monsters. Cats' vocal range encompasses mews, trills, miaows, as well as guttural war cries and unearthly yowls. Their acute senses make them seem attuned to otherworldly phenomena.

It is thus no wonder that enchanted felines run rampant through the folklore, historical records, and popular culture of Japan. Some are connected with *yamaneko*, wild cats that dwelt in the mountains, others are beloved pets that turn against humans. Two kinds of supernatural cats that appear frequently are *bakeneko* and *nekomata*. *Bakeneko* is a species of *bakemono*, encompassing ghosts, goblins, demons, and monsters. *Bakeneko* and *bakemono* are compounds of the verb stem *bakeru*, meaning to change shape or to disguise oneself, and *mono* means thing. *Bakeneko* may curse and possess people, and become vessels for a humans' vengeful spirits.

The distinction between *bakeneko* and *nekomata* is not always clear; some sources describe *nekomata* as being a more diabolical species of *bakeneko*. The key attribute of the *nekomata* is its bifurcated tail (*mata* means the fork of a road or tree, or in this case, tail). They engage in humanoid behavior, such as speaking, walking or dancing on their hind legs,

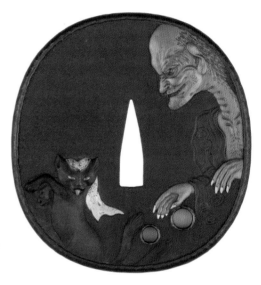

ABOVE **Tsuba (sword guard) with Enchanted Feline, 18th century.** *Iron, gold, silver, copper. 3⅜ in (8.6 cm) x w. 3⅛ in (7.9 cm) x ¼ in (0.6 cm). The Metropolitan Museum of Art, Bequest of Edward G. Kennedy.*

OPPOSITE **Utagawa Yoshifuji, 1828–1887.** *The Supernatural Cat of the Tōkaidō, ca. 1847–1852. Published by Kita. Woodblock print, ink and color on paper, 14½ x 10 in (36.7 x 25.5 cm). Fine Arts Museums of San Francisco, Museum purchase, Achenbach Foundation for Graphic Arts Endowment Fund.*

and wearing a *tenugui* or hand towel draped over their heads. *Nekomata* are said to be female cats who become possessed upon reaching a certain age, and having the ability to shapeshift, usually into the form of a beguiling women. As such, they suggest a darker aspect of the association between women and cats. This also connects them with *tsukumokami,* old household articles and tools that turn into resentful spectres after being carelessly abandoned by ungrateful owners.

Accounts of *nekomata* can be found in records from as early as the Kamakura period. Fujiwara no Teika wrote in his diary that on the second night of August 1233, a *nekomata,* described as a beast from the mountains with two tails, eyes like a cat, and a large body like a dog, attacked and devoured eight people in Nara.

A passage from *Essays in Idleness (Tsurezuregusa,* 1331) by the monk Yoshida Kenkō (1282–1352) mentions rumors of the same creature. "Someone claimed that deep in the mountains there lived a man-eating beast called the *nekomata.* Someone else said, 'It's not only in the mountains. They say that even around here when a cat reaches an advanced age it turns into a *nekomata* and will eat people'" (trans. Donald Keene, 1967). Kenkō follows this with a wry anecdote of a monk, who after hearing such talk, believed himself to be under attack from a *nekomata* on his way home late at night and fell into a pond. The fearsome beast that leapt up at him turned out to be his family dog. The acceptance of spiritual forces in everyday life in premodern times did not preclude a healthy dose of scepticism.

The Tales of Sorori (Sorori Monogatari, 1663) contains a story titled "About a Nekomata" in which

a hunter, lying in wait for his quarry to appear, is warned by a mysterious creature resembling his wife of a coming storm. Suspecting a trap, the man fires an arrow at the strange apparition. When he returns home, there is blood on the front door, but his wife is apparently unharmed. Footprints lead him to the corpse of a monstrous cat.

During the Edo period, demon cats were included among other supernatural creatures in a genre of painted handscrolls called *bakemono zukushi*, or visual compendia of *bakemono*. Several versions include an anthropomorphic cat strumming a shamisen. The unknown artist of a scroll at Brigham Young University has given her a head of human-like hair, tricolor fur, a wide feline nose, and plump, paw-like hands. The tips of a paw and a single tail protrude from beneath the hem of a sumptuous red robe. The inscription above identifies the creature as a *nekomata*, but the shamisen, an instrument associated with the red-light district, links the image with ghost stories of *bakeneko yūjo*, shape-shifting cats who assume the guise of prostitutes in order to prey on men.

Nekomata, detail from *Index of Bakemono*, **ca.1660.** *Handscroll, ink, color, and gold on paper, 17³⁄₁₆ x 600³⁄₈ in (44 x 1525 cm). Brigham Young University, L. Tom Perry Special Collections of the Harold B. Lee Library.*

Chapter Six

Mass-produced woodblock printed media, above all Toriyama Sekien's best-selling four-book compendium, first published 1776–1784, disseminated imagery of supernatural cats and other *bakemono* widely. The title of Sekien's book, *Night Parade of a Hundred Demons*, is drawn from a sub-genre of Japanese painting that coalesced by the 15th century depicting various kinds of supernatural creatures and enchanted objects cavorting through the night, typically along the length of a painted handscroll. Rather than the parade, Sekien conceived his books as compendia with pictures, names, and in the latter volumes, captions for various monsters from literary works and folk traditions. The comically grotesque images resonated with the irreverent spirit of Edo-period humor.

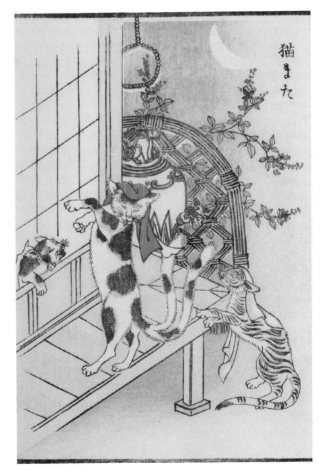

Nabeta Gyokuei (1847–?), *after Toriyama Sekien Nekomata, from Illustrated Book of Monsters (Kaibutsu ehon), 1883. Published by Wada Mojūrō. Woodblock printed book, ink and color on paper, 8⅝ x 5⅞ in (21.80 x 15.10 cm). The British Museum © The Trustees of the British Museum.*

The Kabuki Cat of Okazaki

A key source for imagery of demonic felines was popular fiction and the kabuki stage, whose outlandish plots often claimed to be based on true stories. The villainous Cat Demon of Okazaki was introduced in an act of the blockbuster *Traveling Alone Along the Fifty-three Stations* (*Hitori Tabi Gojūsan Tsugi*) written by playwright Tsuruya Nanboku IV. Opening at Edo's Kawarasakiza Theater in the sixth month of 1827, the play starred Onoe Kikugorō III, who made the cat demon one of his signature roles.

The plot weaves together several urban and regional legends of haunted inns and temples, murderous crones, shape-shifting felines, and a stone resembling a cat, at locales along the Tōkaidō highway linking Edo and Kyoto. A group of travelers break their journey at a derelict temple in Okazaki, where they are welcomed by an old woman in court dress and her cats, who dance on their hind legs. In a pivotal moment, a lamp casts the woman's

LEFT **Utagawa Kagematsu, act. ca. 1830s–40s.** *Souvenirs of the Eastern Capital from among the Fifty-three Stations: Onoe Baikō III as the Demon Cat in the Old Temple, 1841. Published by Wataya Kihei. Woodblock print, ink and color on paper, approx. 15⅜ x 10⅝ in (39 x 27 cm). Collection of Hendrick Lühl.*

RIGHT **Toyohara Kunichika, 1835–1900.** *The Scene at Okabe: Sawamura Tosshō II as Inabanosuke and the Cat Demon, 1860. Published by Daikokuya Kinzaburō. Woodblock print, ink and color on paper, approx. 15⅜ x 10⅝ in (39 x 27 cm). Image courtesy of Egenolf Gallery.*

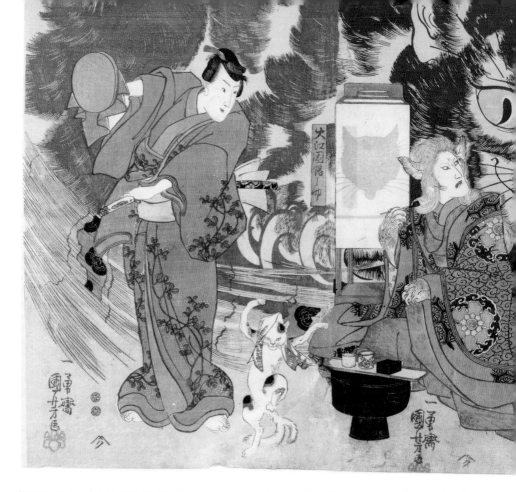

Utagawa Kuniyoshi, 1798–1861. *The Origin Story of the Stone Cat at Okazaki, Representing One of the Fifty-three Stations of the Tōkaidō, 1847. Triptych of woodblock prints, ink and color on paper, 14½ x 29⅛ in (36.8 x 74 cm). Chazen Museum of Art, Bequest of Abigail Van Vleck.*

shadow—the silhouette of a cat lapping the oil—revealing her to be a demon. Now transformed into a giant cat, she begins killing off her guests before she is interrupted by a sword-wielding hero, and she flees into the night. The woman is said to have been possessed by the "spirit of the stone cat."

Every bit as thrilling as the plots themselves,

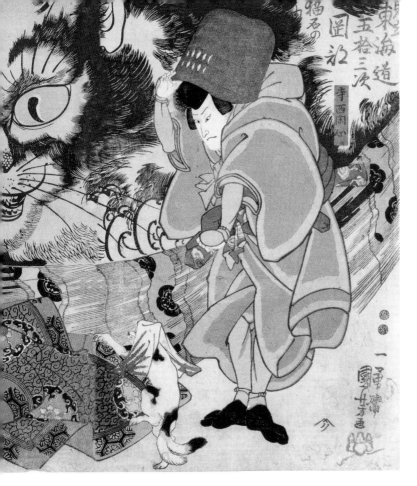

these woodblock prints depict climactic scenes from productions derived from Nanboku's original play, including *Plums in Spring and the Fifty-three Stations* (1835) and the tribute show, *The Lifetime of Onoe Kikugorō III* (1847). Kuniyoshi created multiple designs of a pivotal moment of the narrative in which a gigantic cat conjured up by the Spirit of the Cat Stone breaks through the bamboo blinds of the temple to attack the travelers. His student Yoshifuji conceived a fantastic image of the composite of nine smaller cats, as if this powerful demon is able to spawn clones of itself at will (page 115). The demon cat's eyes are bells, the protruding tongue a silk collar.

The Cat Demon of Saga

The Cat Demon of Saga is a chilling character popularized in the period horror-drama *The Story of the Cat Demon of Fair Saga* (*Hana Saga nekomata zōshi*) written in 1853 by Segawa Jokō III (1806–1881) and staged at the Nakamura Theater the following year. The plot embellishes legends of curses that haunted the Nabeshima family after it wrested control of Saga domain from the older Ryūzōji clan in the late 16th century, known collectively as the "Nabeshima Disturbance." The lord of Saga challenges Ryūzōji Matashichirō, who has been reduced to serving as a retainer of the Nabeshima, to a game of *gō*, but is defeated and kills his opponent in a fit of rage. Meanwhile, Matashichirō's widowed mother has been confiding her resentment towards the Nabeshima and her concerns for her son in the family cat. When she learns he has been killed, she commits suicide. The cat licks up her mistress's blood and is possessed by her vengeful spirit, or *onryō*, thus becoming a *bakeneko*. Assuming the appearance of the lord of Saga's consort, the *bakeneko* torments him night after night. The demon is dramatically revealed to the retainer Komori Hanzaemon when he observes the consort catching a fish from a pond in the palace grounds with her hands, licking lamp oil (made from fish), or casting her shadow by lamplight, depending on the version of the narrative.

Productions based on Segawa Jokō's play and the various spin-offs that followed were imaginatively commemorated in many prints. A triptych by

Yōshū Chikanobu, 1838–1912. *The actors Bandō Shikua as the lord of Nabeshima's mistress, Nakamura Tokizō as Takaki Sanpei, Sawamura Hyakunosuke as the Cat Demon, Suketakaya Takasuke as Omori Hanzaemon, Ichikawa Kanjūrō as Itō Sōta, 1880. Published by Matsushita Heibei. Triptych of woodblock prints, ink and color on paper, 14⅜ x 29½ in (36.5 x 74.9 cm). Image courtesy of Egenolf Gallery.*

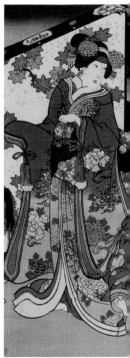

ABOVE **Yōshū Chikanobu, 1838–1912.** *The Cat Ghost of Saga, from the series Competition of Day and Night on Eastern Brocade, 1886. Published by Tsunajima Kamekichi. Woodblock print, ink and color on paper, 14⅝ x 10 in (37.2 x 25.4 cm). Image courtesy of Egenolf Gallery.*

ABOVE **Utagawa Kunisada, 1786–1865.** *Actors Ichikawa Danjūrō VIII as Itō Sōta (R), Ichikawa Kodanji IV as the Widow of Saga (C), and Onoe Baikō IV as the Concubine Kochō (L), 1853. Published by Yamamoto Heikichi. Triptych of woodblock prints, ink and color on paper. Each sheet approx. 15⅜ x 10⅝ in (39 x 27 cm). Tsubouchi Memorial Theatre Museum, Waseda University.*

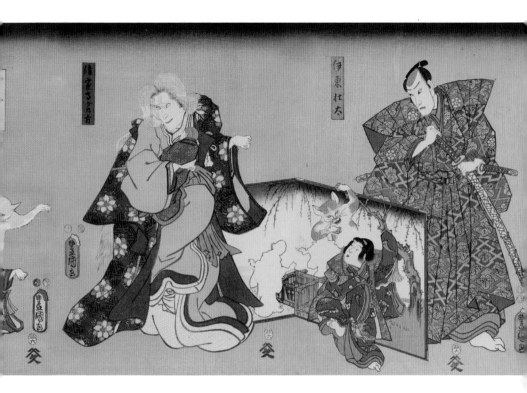

Kunisada shows Ichikawa Kodanji IV in the role of the widow, a baby clutched in one arm, leading a mad dance with cats and children that appear to have materialized out of a painting on a folding screen. Also by Kunisada, the vertical diptych on page 127 has Kodanji, wearing prosthetic ears, paws, and a forked tail, attempting to flee the sword of the valiant retainer, Itō Sōta, in a plume of smoke.

In the version of the story referenced by Chikanobu's print on page 124, the lord of Saga orders a night watch to protect him against the Cat Demon, but his guards repeatedly succumb to sleep. Itō Sōta volunteers, and to combat drowsiness, plunges his dagger into his thigh, as depicted. When the lord's consort appears, Sōta sees that her shadow is that of a demoniac feline.

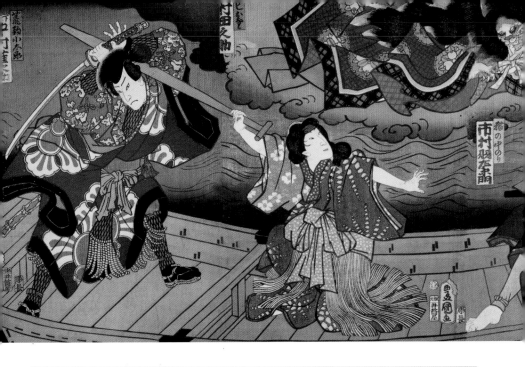

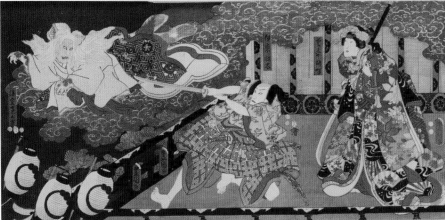

Chapter Six

LEFT **Utagawa Kunisada, 1786–1865.** *The actors Nakamura Shikan IV as Suwa Kazuemon (right), Ichimura Uzaemon XIII as the cat in flight (above), Sawamura Tanosuke III as the Fisherwoman Onami (center), Nakamura Jakunosuke as Arakoma Kotarō (left) from the play A Syllabary Diary of the Tōkaidō (Tōkaidō Iroha Nikki), 1861. Published by Izutsuya Shōkichi. Triptych of woodblock prints, ink and color on paper. Each sheet approx. 15⅜ x 10⅝ in (39 x 27 cm). National Diet Library, Tokyo.*

LEFT **Utagawa Kunisada, 1786–1865.** *Actors Onoe Baikō IV as the Concubine Kochō (R), Ichikawa Danjūrō VIII as Itō Sōta (C), and Ichikawa Kodanji IV as the Widow of Saga (L), 1853. Published by Kiyomizuya Naojirō. Triptych of woodblock prints, ink and color on paper. Each sheet approx. 15⅜ x 10⅝ in (39 x 27 cm). Tsubouchi Memorial Theatre Museum, Waseda University.*

RIGHT ABOVE AND BELOW **Utagawa Kunisada, 1786–1865.** *The Widow of Saga, 1853. Published by Kurokiya Heikichi. Vertical diptych of woodblock prints, ink and color on paper. Each sheet approx. 15⅜ x 10⅝ in (39 x 27 cm). Upper sheet: Rijksmuseum, Mr H.J. Herwig and Mrs A.H. Herwig-Kempers, lower sheet: Tsubouchi Memorial Theatre Museum, Waseda University.*

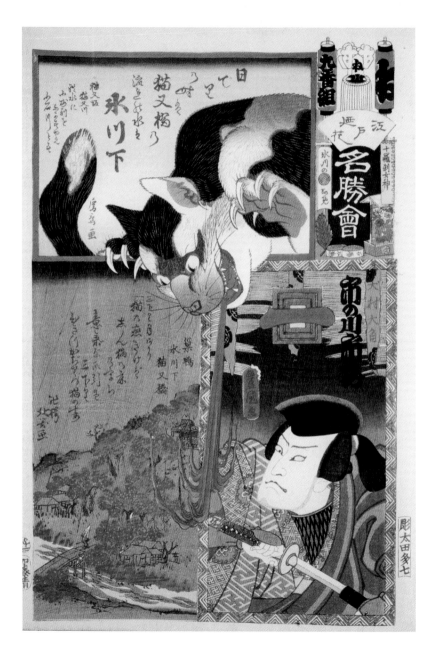

Monster Cats Vanquished by Warriors

Nekomata Bridge (Nekomata-bashi) once spanned the Sengawa river, which flowed along the base of a slope in what is now Tokyo's Bukyō ward. Other than two large stones, the bridge is now gone, but the slope remains known as Nekomata Hill (Nekomata-zaka). Kuniyoshi's print, featuring a fierce, fire-breathing monster cat, conflates Edo's Nekomata Bridge with the unrelated story of the monster cat of Mt Kōshin, slayed by Ichinokawa Ichizō in *The Lives of the Eight Dogs of the Satomi of Southern Kazusa*.

According to some sources, the name Nekomata-bashi originally referred to its construction from the forked root of a tree, but over time became written using characters that referred to the more compelling demon cat. The topographical guidebook *Sands of Edo: Sequel* (*Zoku Edo sunago*, 1735) reports of strange sightings of dancing tanuki and other enchanted beasts at this location. In those days, the Chinese characters used to write tanuki could also mean cat, thus the association of the bridge with *nekomata* was strengthened.

Another origin story for the bridge concerns the beloved cat belonging to a silk merchant in the Kanei era (1624–44). While the merchant and his wife were mourning the death of their infant son, a baby boy was left on their doorstep. They named the child Monjirō and raised him as their own. Tragedy struck again when the merchant was murdered. When Monjirō was a teenager, he moved with his mother and the cat to Edo and began training as a swordsman with the

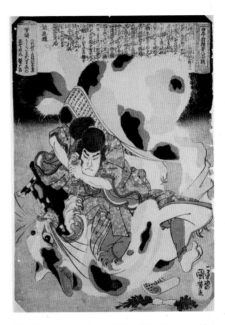

ABOVE **Utagawa Kuniyoshi, 1798–1861.** *The One and Only Eight Dog History of Old Kyokutei, Best of Refined Utagawa Authors: Inumura Daikaku, 1836. Published by Nishimuraya Yohachi. Woodblock print, ink and color on paper, approx. 14¾ x 10 in (37.5 x 25.5 cm). The National Museum of Ethnology, Leiden.*

OPPOSITE **Utagawa Kunisada I (Toyokuni III), 1786–1865; Katsushika Isai, 1821–1880; Katsushika Hokuen, active 1860s.** *Ne Brigade, Ninth Group, Nekomatabashi: Actor Ichinokawa Ichizō as Inumura Daikaku, from the series Flowers of Edo and Views of Famous Places, 1864. Published by Katōya Iwazō. Woodblock print, ink and color on paper, approx. 15⅜ x 10⅝ in (39 x 27 cm). National Diet Library, Tokyo.*

intent of avenging his father's death.

Once settled into their new abode, the cat began bringing home gold coins, night after night, which Monjirō, otherwise destitute, used to keep his household alive. The source of the coins was the coffer of a pawnbroker, who killed the cat when he discovered it had been stealing from him. Upon hearing this, Monjirō visited the pawnbroker to recover the body of his father's cat.

The pawnbroker was astonished by Monjirō's resemblance to his dead wife, and immediately recognized him as the son he had abandoned many years before on the doorstep of the silk merchant. After avenging his adoptive father's death, Monjirō constructed Nekomata-bashi in memory of the thieving cat who kept his family alive and orchestrated the reunion between birth father and son.

On page 129, a calico cat of unnatural size and forked tail writhes beneath the sword of Inumura Daikaku Masanori, one of the eight heroes of Takizawa Bakin's best-selling novel *The Lives of the Eight Dogs of the Satomi of Southern Kazusa* (*Nansō Satomi Hakkenden*, serialized 1814–1842). Running to over one hundred volumes, the epic follows the adventures of eight heroes, the mystic progeny of Princess Fuse and her canine husband Yatsufusa. The story was enormously popular and inspired many adaptations and imitations in literature, theater, and print.

The monstrous cat in Kuniyoshi's design is an evil shapeshifting *yamaneko* or mountain cat that years before killed Daikaku's father and assumed his form, making this episode a relatively unusual case of feline possession of a man. After years of mistreatment from his false father, the ghost of Daikaku's real father appears to him and exhorts him to avenge his

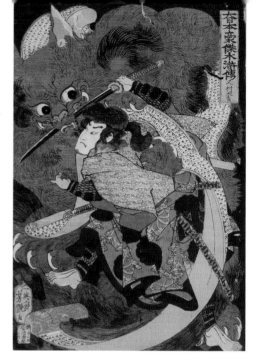

death. Filial and stout of heart, Daikaku attacks the creature while still in human form. He wounds it, and it reverts to its true state as a gargantuan demon cat.

Kamada Matahachi is a strongman featured in several plots in the *kurohon* ("black book") genre of light fiction. A native of Matsuzaka in present-day Ise prefecture, Matahachi travels to Edo where he performs feats of superhuman strength. On page 131, he is depicted vanquishing a monstrous cat that lurked in the mountains of Seishū. The episode is drawn from the book *Kamada Matahachi Exterminates the Monsters* (*Kamada Matahachi bakemono taiji*, 1769), in which he battles various demons, culminating with a monstrous cat that has eaten an elderly woman and assumed her form.

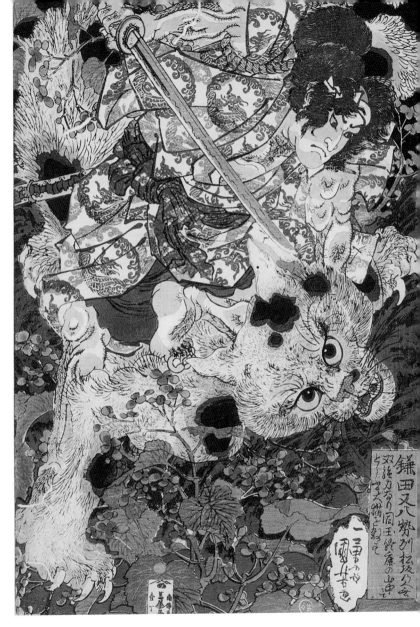

LEFT **Utagawa Yoshitsuya, 1822–1866.** *Heroes of Great Japan: The Water Margin: Inumura Daikaku,* ca. 1850s. Published by Kiyomizuya. Woodblock print, ink and color on paper, approx. 15⅜ x 10⅝ in (39 x 27 cm). Tsubouchi Memorial Theatre Museum, Waseda University.

RIGHT **Utagawa Kuniyoshi, 1798–1861.** *Kamada Matahachi Killing a Monstrous Cat in the Mountains of Ise Province,* ca. 1840. Published by Tsutaya Kichizō. Woodblock print, ink and color on paper. approx. 15⅜ x 10⅝ in (39 x 27 cm). Tsubouchi Memorial Theatre Museum, Waseda University.

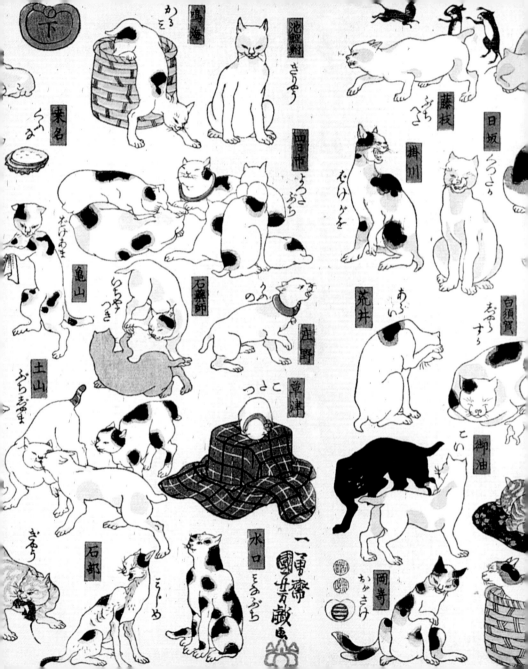

CHAPTER SEVEN

Cats in Humor and Satire

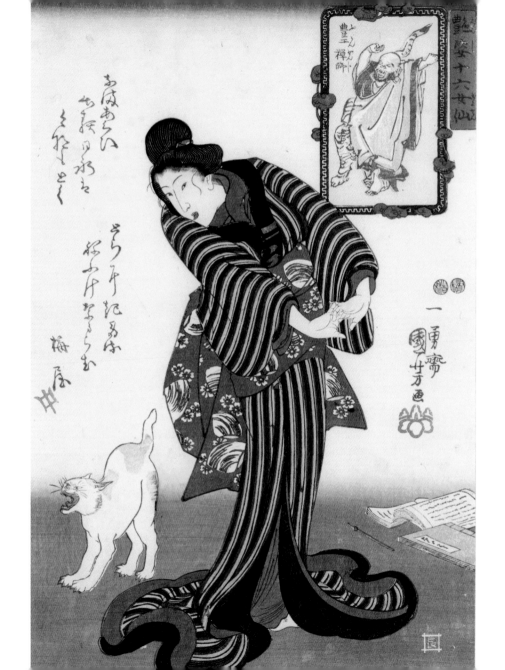

God and Immortals

Long before the age of the Internet, humans bonded in delight and hilarity over the antics and attitudes of cats, and amused themselves by projecting their own thoughts, emotions, and desires onto these most intimate of domestic animals. In Japan, the oldest images of cats are found in the comical *Scrolls of Frolicking Animals* (*Chōjū-jinbutsu-giga*, ca. 1200). Among frogs, rabbits, monkeys, and other animals engaging in human activities like sumo wrestling, religious ceremonies, and swimming are three long-tailed tabbies that appear to be satirizing the activities of Buddhist or Shinto priests.

Introducing images, mostly ukiyo-e from the mid- to late-19th century, of whimsical humor, absurdity, and irreverence, this section suggests how Japan's parlor panthers entertained and surprised their human companions with their curiosity, playfulness, and spiritedness, and presented an appealing subject through which to chuckle at themselves and poke fun at authority figures. Although viewers today may require some explanation to grasp the subtext or nuances of these prints, the humor arising from the artists' deft depictions of the animals, the

absurd situations they find themselves in, and recognizing ourselves in their deeds and expressive faces, transcends time and place.

Two prints by Kuniyoshi contrast women and their pet cats with Daoist immortals, called *sennin*. The Chinese monk Bukan (Ch.: Fenggan) was notorious among his brethren for taming a tiger and riding it to the monastery. Pictures of Bukan and his striped beast dozing affectionately together are a popular theme of Buddhist imagery. Kuniyoshi imagines human and feline members of these two pairs arising from a nap. With its tail aloft, ears flattened, whiskers on end, and teeth and tongue bared in a wide yawn—the cat humorously mirrors its mistress's pose. The inscribed poem explains that the pair are drowsy because they woke up at the hour of the tiger (equivalent to four am).

The "toad" refers to Gama Sennin (Ch.: Liu Hai), literally the "Toad Immortal," depicted carrying his constant companion, a magical three-legged white

LEFT **Utagawa Kuniyoshi, 1798–1861.** *The Zen Priest Bukan, from the series Sixteen Charming Female Immortals, ca. 1847. Published by Aritaya Kiyoemon. Woodblock print, ink and color on paper, approx. 14⅞ x 9¹³⁄₁₆ in (38 x 25 cm). Image courtesy of Egenolf Gallery.*

PREVIOUS SPREAD **Utagawa Kuniyoshi, 1798–1861.** *Puns Just Like This: The Fifty-three Cats of the Ailurophile, 1847–52. Published by Ibaya Sensaburō. Triptych of woodblock prints, ink and color on paper, 14⅝ x 30 in (37.1 x 76.2 cm). Public domain.*

toad, in the inset window above. Gama Sennin was said to be able to release his soul from his body, shapeshift, and fly. In the main image, a young woman carries her cat over her shoulder in emulation of the immortal.

Below, legendary Empress Jingū, dangling a fishing rod, and Ebisu, the god of fishermen and good fortune, are absorbed in a spirited game with a cat. The image is a playful reference to an episode in *The Chronicles of Japan* (*Nihon Shoki*, completed 720),

one of Japan's oldest surviving historical texts. The Empress Jingū is thought to have served as regent between her husband's death in 201 and her son's coming of age. Having aggressively expanded her territories, Jingū is poised to invade the "promised land"—sometimes thought to be the Silla Kingdom on the Korean Peninsula. She prays to the gods for a sign, casts a fishing line into a river, and hooks a trout—or in this retelling, a cat.

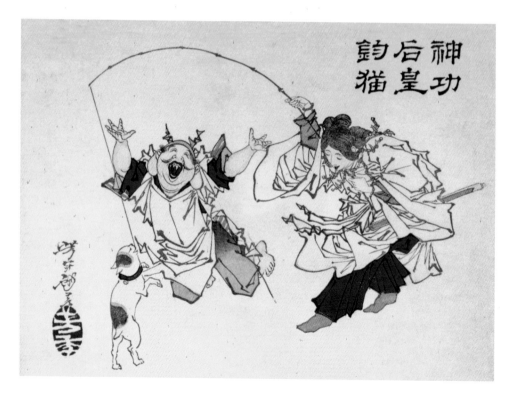

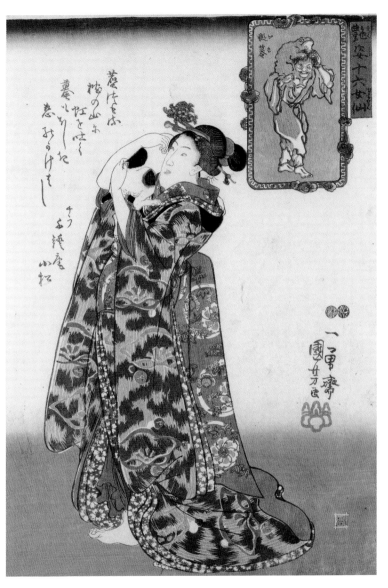

Tōkaidō Road Cats

Sugoroku is a board and dice game analogous to snakes and ladders, traditionally played by families during the New Year holiday. In this example, players begin on the starting square in the lower right, depicting a cosy scene of a mother cat and her two kittens, and compete to reach the finishing box at center, titled "the lap of celebration," in which cats play music, dance, feast, and toast with cups of sake. Along the way, players land on squares representing good fortune—such as basking in the sun or "catching" a fish, and mishaps, like being chased by a child with a stick or receiving a scolding for sharpening one's claws on the sliding paper doors.

The concept and title of the board game parody the comic novel, *Along the Tōkaidō on Shanks' Mare* (1802–1822) by Jippensha Ikku (1765–1831), a ribald adventure of two friends traveling the Tōkaidō highway, connecting Edo (modern-day Tokyo) and Kyoto, on foot.

The triptych print by Kuniyoshi on pages 132–133 is one of the most reproduced images of cats in Japanese art. The design puns the activities, attributes, and thoughts of cats with the names, contained in red cartouches, of the fifty-three post stations along the Tōkaidō, where travelers could find lodging, food and entertainment.

The Japanese title of the print replaces "Tōkaidō" with the invented word *myōkaidō*, written with Chinese characters to mean "cat fancier."

Utagawa Yoshifuji, 1828–1887. *A Lap Cat's Sugoroku, ca. 1880s–90s. Published by Ōhashi. Woodblock print, ink and color on paper, approx. 14⁹⁄₁₆ x 18⁷⁄₈ in (37 x 48 cm). Tokyo Metropolitan Library.*

Utagawa Kuniyoshi, 1798–1861.
Bonito, from the series Cats' substitute characters, ca. 1842. Published by Ibaya Senzaburō. Woodblock print, ink and color on paper, 14¼ x 9¹⁵⁄₁₆ in (36.2 x 25.3 cm). The British Museum, donated by American Friends of The British Museum © The Trustees of the British Museum.

The viewer begins their journey at Nihonbashi, represented by a piebald cat absconding with two dried bonito (*nihon dashi*), and arrives at Kyoto (Kyō) with a ginger tabby that has caught a mouse, which cries "*gyū!*" as it is crushed between the cat's jaws. Along the way, they encounter a cat at Ōiso, who exclaims "this thing is heavy!" (*omoizo*) as it drags off a gigantic squid. Below, at Mishima, a calico with the forked tail of the demonic *nekomata* dances on its hind legs with a towel over its head. The inscription reads *mikema*—meaning "calico witch." At the top of the center sheet, for Mariko, is a papier mâché figurine (*hariko*). Below, for Mitsuke, a brown tabby curled into a ball falls asleep (*netsuki*) on a cushion, and to the right, for Yoshida, a white and tan cat awakens (*okita*) with a yawn and a stretch.

While Kuniyoshi's wordplay tends towards the groan-inducing, he demonstrates his sensitive eye for feline subjects and sharp wit as a caricaturist. Many of the individual cats featured in the design appear in earlier prints by Kuniyoshi; as such, the design distilled the feline appeal of his broader corpus for his cat-fancying fans.

In the print on the left, eleven kittens and three fish spell out the syllables かつお (*katsuo*), meaning bonito. At the top, one wears a paper sweets bag on its head like a hat. The cats' comically distorted forms and smiling faces are characteristic of Kuniyoshi's inventiveness and sense of fun.

Kabuki Star Cats

In 1842, as part of a sequence of sumptuary laws called the Tenpō reforms (1841–43), authorities forbade the publication of actor portraits. Kuniyoshi circumvented government censors by creating designs in which kabuki stars were caricatured as animals, including turtles, goldfish and especially cats. He already had some experience with this—in 1841, he and the writer Santō Kyōzan launched the illustrated serialized novel *Hazy Moon Cat Tales* (1841–49), which featured cats cast into kabuki plotlines. The absurdist humor and biting satire of Kuniyoshi's new designs must have delighted the public, as he continued to produce new pictures following this principle well after the laws ceased to be enforced.

Utagawa Kuniyoshi, 1798–1861.
Parody of Umegae Striking the Bell of Limitless Hell, from the series Fashionable Cat Games, ca. 1847–48. Published by Yamamotoya Heikichi. Woodblock print, ink and color on paper, 13¹⁵⁄₁₆ x 9⅝ in (35.5 x 24.4 cm). The British Museum © The Trustees of the British Museum.

The prints on pages 141 and 142 by Kuniyoshi draw from his illustrations for episodes in the *Hazy Moon* books. Umegae, a self-sacrificial heroine, has sold herself into prostitution to raise money to recover the armor of her lover from a pawnbroker, but remains three hundred gold coins short. Remembering a legend of a bell that when rung delivers untold riches but also condemns one to eternity in hell, she strikes a water basin in the garden with a ladle. To her surprise and wonder, coins rain down from above. Instead of a water basin, Kuniyoshi's feline Umegae, a caricature of the actor Sawamura Sōjūrō V, smacks the head of an octopus, whose eyes widen and tentacles writhe in pain. Dried fish fall from the sky. The name Umegae means "plum branch," and the role is typically costumed in a kimono patterned with plum blossom; here, Kuniyoshi fashioned the floral motif from looped cat collars and bells.

A second print from this series features caricatures of the actors Bandō Shiu and Ichikawa Kyūzō II in the roles of the lovers Matsuyama and Kubei during the travel scene from the play *A Shared Umbrella of Plum and Willow* (*Ume yanagi tsui no aigasa*). Again, Kuniyoshi included playful details, patterning the characters' garments with feline-appropriate motifs of butterflies and cat bells, and forming the petals and leaves of the plant in the lower right from clam shells and filleted fish.

Utagawa Kuniyoshi, 1798–1861. *Parody of the Michiyuki in the Play Pussywillow Blooming by Moonlight, from the series Fashionable Cat Games, ca. 1847–48. Published by Yamamotoya Heikichi. Woodblock print, ink and color on paper, approx. 14⅞ x 9¹³⁄₁₆ in (38 x 25 cm). Tsubouchi Memorial Theatre Museum, Waseda University.*

The print above is modelled after a *banzuke*, a table of rankings devised to record the relative status of actors, prostitutes, sumo wrestlers, restaurants, and virtually anything else the floating world had to offer. The title contains a pun—the second character in the word for "strange" or "fantastic," *chinmyō*, is substituted with the character for "cat." In this spirit, the artist Kunichika represented top actors of the day as a crowd of anthropomorphic cats (and one rat), each in a warrior-type role from the kabuki stage. The rectangular cartouches identify the actors, characters, and their respective fees.

The top register, resembling an unfurling scroll titled "Nagashima Shungyō's records," contains an extensive list of names of characters, each identified by their traits—from "loyal" to "villainous," and the region they are associated with.

Toyohara Kunichika, 1835–1900. *A Fantastic Parodic Comparison of Good and Evil, 1884. Published by Fukuda Tamotsu. Triptych of woodblock prints, ink and color on paper. Each sheet approx. 14³⁄₁₆ x 9⅝ in (36 x 24.5 cm). Tsubouchi Memorial Theatre Museum, Waseda University.*

Cats in School, Bathing Cats, and Catrobatics

As part of its policy of "civilization and enlightenment," aimed at modernizing Japan along Western lines, Japan's Meiji government introduced universal national education in 1872. This print, a charming schoolhouse scene, is an artifact of this period. At the bottom, feline students trickle through the iron gates of a school, frolic in the playground, before the serious business of learning begins in the upper two levels. The pupils are divided by gender—male students in the upper story appear to be engrossed in a lesson on world geography, while below them, female students are perhaps learning the English words for objects illustrated on a wallchart. Consistent with the distinctive fashions of the day, the students are depicted wearing a mixture of Japanese and Western clothing, such as trousers, jackets, and hats, and one late comer carries a silk umbrella. Several of the female students sport *hakama*, a type of bifurcated skirt worn over the kimono. Adapted from menswear, the *hakama*, which ostensibly allowed greater freedom of movement than a kimono alone, was adopted as a uniform for female students and teachers in the Meiji era.

Visiting the public bathhouse was a fixture of social life and wellbeing in early modern Japan. Even in the era of modern plumbing, communal bathing, whether at the neighborhood bathhouse or a mountain resort, remains a popular mode of relaxation and recreation. Cats, notorious for their fastidious groom-

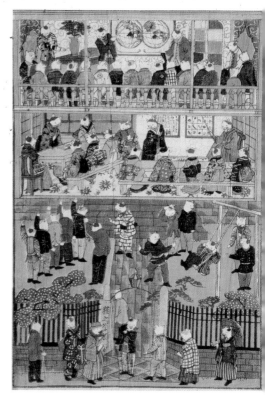

Utagawa Kunisada III (Kunimasa IV). *New Edition: School for Cats, 1876. Woodblock print, ink and color on paper, 14³⁄₁₆ x 9³⁄₁₆ in (36 x 23.3 cm). Honolulu Museum of Art, Gift of Oliver Statler, 2003.*

Utagawa Yoshifuji, 1828–1887. *Newly Published: Hot Spring for Cats, 1888. Published by Ozeki Toyo. Woodblock print, ink and color on paper, approx. 14⅞ x 9¹³/₁₆ in (38 x 25 cm). Image courtesy of Shukado Gallery.*

ing habits and aversion to water, of course have no need for hot springs; therein lies the humor of the great variety of prints of cats enjoying the bathhouse published and republished in the 1880s–90s.

In Yoshifuji's image, a blue *noren* or entryway curtain proclaims the name Matatabi-yu— *matatabi* being the dried stalk of silvervine (*Actinidia polygama*), which, like catnip, elicits a euphoric response in felines, while *yu* means hot water. The design of the *noren* features a string of bells and a bundle of the intoxicating herb. A mother and daughter cat, dressed in ki-mono, their ablutions complete, are distracted as they depart by a stall at the bathhouse gates. Within the bathroom, cats young and old scrub themselves with towels, pour steaming buckets of water over each other, and soak in the tub. A bathhouse employee gives the back of a client a vigorous rub.

Overleaf, a variety of street performers are represented as calico cats—acrobats and tumblers, fan dancers and jugglers, drummers and shamisen strummers, cats blowing bubbles and selling butterflies crafted from paper and bamboo. Interspersed among them are specta-tors—feline mothers, fathers, and their kittens.

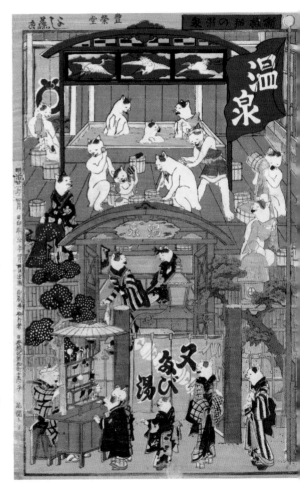

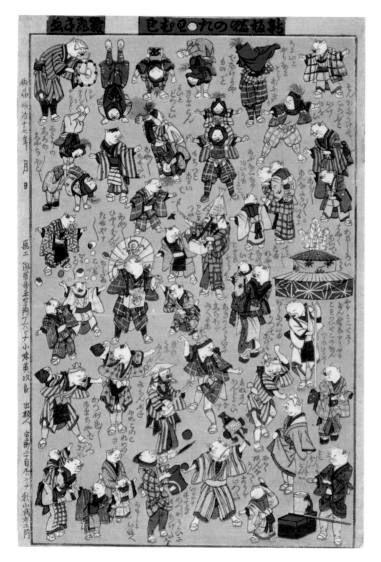

LEFT **Kobayashi Ikuhide, active ca. 1880–1898.** *New Edition: Cats at Play, 1884. Published by Akiyama Buemon. Woodblock print, ink and color on paper, approximately 14⁷⁄₁₆ x 9⅝ in (36 x 24.5 cm). Image courtesy of Egenolf Gallery.*

OPPOSITE **Utagawa Kunimasa V, 1848–1920.** *Newly Published: Mouse Games, 1882. Woodblock print, ink and color on paper, 14⁹⁄₁₆ x 10 in (37 x 25.2 cm). Image courtesy of Morimiya Gallery.*

Cat and Mouse Games

An extended family of mice is depicted performing acts of mischief and heroism. In the lower register, a group brings sustenance to one of their brethren, who is caught in a metal cage. A female mouse with her young tucked into the back of her kimono—perhaps the wife of the prisoner—dabs her tears with her sleeve.

In the middle register, the mice play tricks on a "retired" cat, whose spectacles dangle from one ear as it dozes. One breaks wind in the cat's face, another pulls his whisker, a third is poised to place a paper bag over its head. A fourth mouse dangles a bell over the cat's head. To the right, two mice befoul the cat's dinner.

In the top register, a brood of baby mice is born. The mother is seated at far right with a blanket over her lap. Other females of the family bathe the new arrivals. The grandparents enter from the far left, raising their front paws in delight. Above, Daikokuten, the god of fortune and wealth, glides down on a swirling cloud to bestow his blessings. Daikokuten is associated with the rat in the Chinese zodiac calendar.

The age-old enmity between cats and mice is imagined as an historic samurai battle by Yoshitoshi (page 148), who like his teacher Kuniyoshi special-ized in warrior subjects. The cats have strength and mouse traps on their side, but the mice are tactical fighters, deploying a papier-mâché dog to spook the cats, trapping their heads in paper sweets bags, bait-

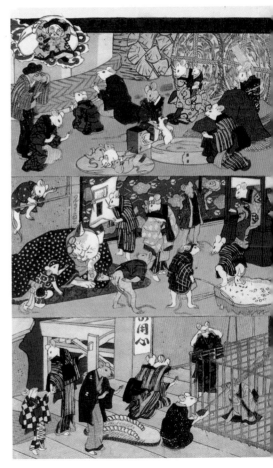

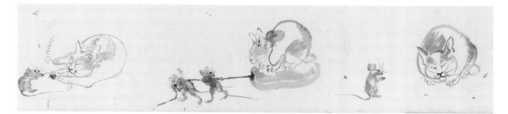

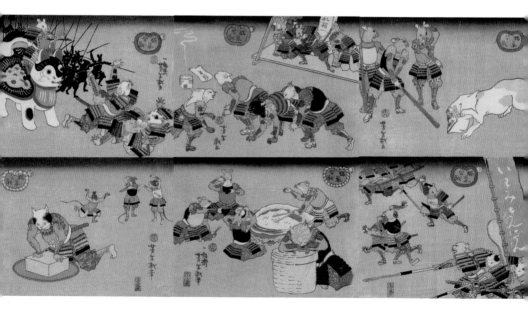

ing them with intoxicating *matatabi*, and plundering their provisions (served, as per custom, in an abalone shell) while the sentry dozes off. The title cartouches are shaped as cat collars.

The handscroll to the left by Kawanabe Kyōsai turns the animosity between cat and mouse into social commentary. One vignette depicts mice straining to haul a cat perched comfortably on a gourd. In another, a mouse with a mischievous glint its eye pulls the whisker of its sleeping enemy. The powerful and complacent cat lords his power over the mice, but when its guard is down, weakness is exposed.

Comical yet terrifying, Yoshifuji's print to the right imagines a hell for mice, modelled on Japanese Buddhist visions of the underworld. A feline King Enma, enthroned and dressed like a Chinese magistrate, at top center, overseas his fiery dominion. Consulting his register of sins, he judges the souls of dead mice and determines what kind of punishment they should receive.

In the lower register, the newly dead arrive on the shores of the Sanzu River, marking the entrance to the afterlife. At left, the hag Datsueba, with the countenance of a cat, collects the clothing of the rodents, which are weighed on the branch of a tree above to determine the gravity of their sins. To the right, the mice stack river stones into pagodas in supplication to Daikokuten, who stands in for the merciful deity Jizō.

Above, feline demons supervise various torments, including the Cauldron Hell in which mice are boiled alive, the Hell of Great Screaming where their tongues are extracted, the Realm of Hungry Ghosts, where they are cursed with insatiable hunger.

Utagawa Yoshifuji, 1828–1887. *Newly Published Comic Picture of Cats, 1883. Published by Matsuno Yonejirō. Woodblock print, ink and color on paper. 14⅝ x 9¹³⁄₁₆ in (37.2 x 25 cm). Museum of Fine Arts, Boston, William Sturgis Bigelow Collection.*

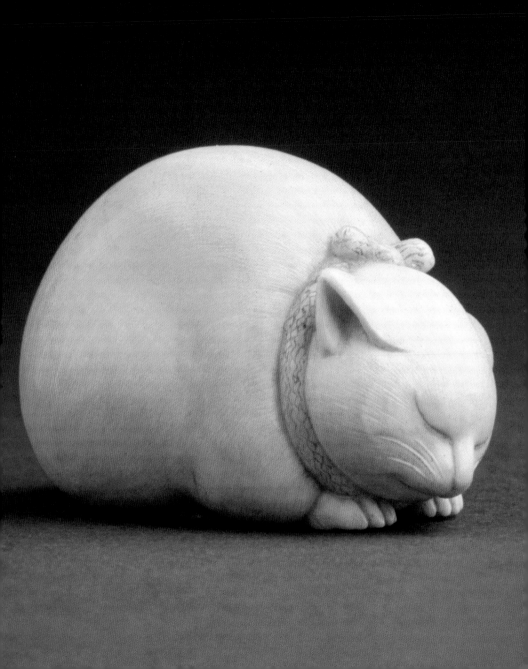

Philosophers' Cats, Teachers' Pets and Moggies with Messages

Feline Symbolism

In East Asian cosmology, the tiger is the third animal of the East Asian zodiac, a pantheon of twelve totemic beasts that protect the earth: rat, ox, tiger, rabbit, dragon, snake, horse, sheep, monkey, rooster, dog, and pig. Regular house-cats, however, were excluded (except in Vietnam, where the cat takes the place of the rabbit)—according to one legend, the cat overslept on the day selection took place. Other legends assert that the cat was the only animal that didn't weep when the Buddha died.

Despite this snub, the cats of Japan have an enduring position in the lap of philosophical, intellectual, and religious thought. The feline image is deployed to represent complex ideas in the most hallowed sites of Japanese history, as agents of enlightenment in Buddhist texts, and as protagonists of tales of folk wisdom. These congenial critters function as appealing narrative aids, impart moral teachings, elucidate human folly, disseminate official truths, and invite meditation.

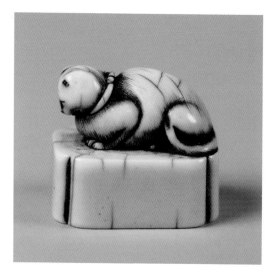

RIGHT **Ōgaki Shōkun, 1865–1937.** *Serving Tray with Cat Sleeping on Lotus Sutra (detail).*

LEFT **Netsuke of Cat on a Seal-Shaped Base, mid- to late-19th century.** *Ivory, slight brown stain, 1 x 1¼ in (2.5 cm x 3.2 cm). The Metropolitan Museum of Art, Edward C. Moore Collection, Bequest of Edward C. Moore, 1891.*

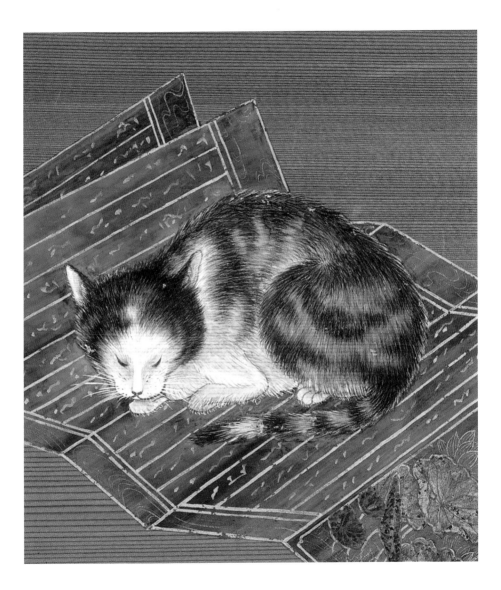

Sleeping Cats

Among Japan's most famous felines is a realistically carved wooden sculpture of a sleeping cat, or *nemuri neko*, created in the early 17th century. The sculpture is part of the elaborate architectural carvings at Tōshōgu, the mausoleum of the first shogun Tokugawa Ieyasu in the town of Nikkō, Tochigi prefecture, north of Tokyo. Designated a National Treasure of Japan, the sculpture is a kitten-sized 20 centimeters (8 inches) in length and surrounded by pink and red peonies. The reverse of the sculpture is carved with a pair of sparrows. Some believe the sleeping cat to be a symbol of peace, as the birds are able to flit about freely, or of protection against rats and other misfortune.

The sculpture is attributed to the apocryphal artist Hidari Jingorō. According to legend, Jingorō lost his right hand, but was either left-handed or so skilled that this injury did not impair his creative output (*hidari* means left). The artist emerged as a people's hero in the Edo period, his life and legacy magnified and embellished by kabuki plots, popular fiction, and ukiyo-e. A triptych by Kuniyoshi depicts the artist surrounded by his many lifelike creations—various Daoist and Buddhist deities, bodhisattvas, and priests, Tengu masks, mythical beasts, and a ghost. It is thought that the sculptures are portraits of kabuki stars, playfully disguised to circumvent prohibitions on representing actors issued as part of the Tenpō reforms. It is also suspected that Kuniyoshi inserted himself into the scene as Jingorō, as the sculptor bares several attributes associated with Kuniyoshi—a haori jacket decorated with scenes of hell, his family crest emblazoned on the robe and patterning his cushion, and the little cat grooming itself by the artist's side. The latter is a reference to Jingorō's celebrated sculpture, but also to Kuniyoshi's well-known affinity for felines.

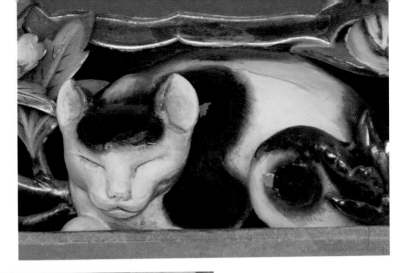

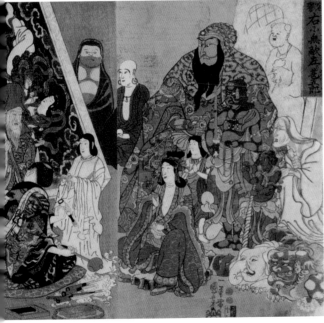

ABOVE: **Sleeping Cat, ca. 1634, Tōshōgu, Nikkō.**

LEFT: **Utagawa Kuniyoshi, 1798–1861.** *The Renowned, Incomparable Hidari Jingorō, ca. 1848. Published by Ebisuya Shōshichi. Triptych of woodblock prints, ink and color on paper, 14⅜ x 29⅛ in (36.6 x 73.4 cm). Library of Congress, Washington D.C.*

Deep asleep the cat lies as if amid "deep grasses" of peony blossoms,
perhaps having a dream in which he is a butterfly!
—trans. John T. Carpenter

As serene as a Buddha, a well-fed cat sleeps. The symmetry of its rotund form is broken only by the tip of its skinny tail resting neatly over its front paws. The cat's haunches protrude like a second pair of ears, giving it a slightly comical aspect. The artist added striped markings of dilute ink with a wet brush. Inscribed to the left is the poem above, composed by the artist.

The poem references a famous passage of *Zhuangzi*, a philosophical text attributed to the Daoist philosopher Zhuang Zhou (ca. 369–286 BCE), in which the narrator dreams of being a butterfly. The dream is so convincing that upon waking, he is unsure if he was a man that had dreamt that he was a butterfly, or was a butterfly now dreaming he was a man. Rather than depicting the philosopher, the artist Hōzōbō Shinkai, a Buddhist monk, alluded to the episode by depicting a much more charming image of a sleeping cat.

Hōzōbō Shinkai, 1626–1688. *Dreaming Cat, mid-17th century. Hanging scroll, ink on paper, 11 x 16 in/27.9 x 40.6 cm (image). The Metropolitan Museum of Art, Gift of Sue Cassidy Clark, in honor of John T. Carpenter, 2019.*

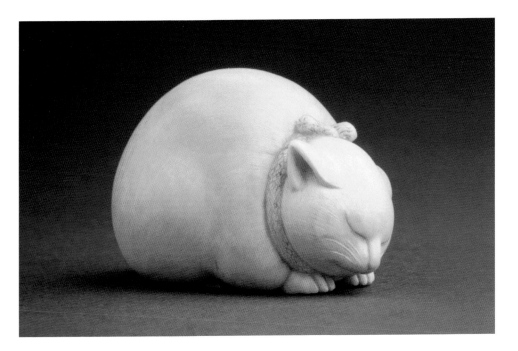

A netsuke is a toggle through which a cord can be threaded, allowing a pouch or case to be suspended from the obi, a sash worn over the kimono. Prior to the adoption of Western-style dress, an attractive netsuke was an essential accessory for any well-dressed gentleman. Netsuke encompass natural objects like dried gourds to elaborately carved sculptures in miniature, the finest examples of which are works of art. Osaka artist Kaigyokusai, who specialized in animal subjects, transformed a hard lump of ivory into the deliciously plump form of a dozing cat. Finely textured to suggest a luxurious coat of fur, its rounded contours appear soft and pillowy. The angled ears, however, suggest that the cat has not quite surrendered to sleep; mice play at their peril.

Kaigyokusai (Masatsugu), 1813–1892.
Sleeping Cat, mid- to late 19th century. Ivory with sumi, red pigment, 1⅝ x 1⅛ x 1 in (4.1 x 2.8 x 2.5 cm). Los Angeles County Museum of Art, Raymond and Frances Bushell Collection.

Almost perfectly circular, this *tsuba*, or sword guard, is charmingly formed as a cat curled in a tight ball. Positioned at the base of the grip of a sword, the *tsuba* is designed to protect the bearer's hand and help to balance the blade. During the relative stability of the Edo period, members of the samurai class, Japan's warrior aristocracy, had few opportunities to draw their weapons in combat, but customarily wore swords as symbols of their elite status. The designs became more ornamental and were often embellished with soft, precious metals and alloys. Like netsuke, they were collected and worn as expressions of personal taste and status, presented as gifts, and treasured as heirlooms. In this example, the cat's collar and whiskers gleam against the softly patinated iron ground. The cat's eyes—closed, or ever so slightly open— hint that this apparently whimsical theme may communicate a message of vigilance during peacetime.

Tsuba in the form of a sleeping cat, mid- to late 19th century. *Iron, gold, shakudō, copper, sekigane, 3 x 2⅞ x ⁵⁄₁₆ in (7.7 x 7.5 x 0.8 cm). Museum of Fine Arts, Boston, William Sturgis Bigelow Collection.*

Life-sized porcelain ornaments, or *okimono*, of sleeping cats were mass-produced for the Western export market between the late 19th and early 20th centuries. This example is distinguished by the naturalistically modelling of the body and the delicate rendering of the cat's facial features, whiskers, and fur in fine brushwork. A red and turquoise collar, applied in overglaze enamels, adds a splash of color.

This artwork is an example of "revived" Kutani ware. The ceramic center of Kutani in Kaga province (present day Ishikawa prefecture) was established in 1656 under the patronage of the ruling Maeda clan. Glazed in distinctive combinations of red, yellow, green, blue, and purple, Kutani porcelains were produced in relatively small quantities for local elites. The kilns were active for only a few decades before they went into decline and were ultimately shut down in the early 18th century. In 1804, the kilns were reopened and production decentralized. With the increase in foreign trade from the mid-19th century, Kutani wares were produced on an industrial scale.

Sleeping Cat; late 19th–20th century. *Porcelain with overglaze enamels, 4 x 9½ x 6⅝ in (10.2 x 24.1 x 17 cm). The John and Mable Ringling Museum of Art, Bequest of John Ringling, 1936.*

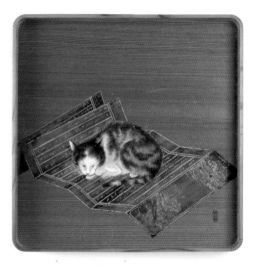

Anyone who has been fortunate to share their home with a cat has observed that their furry companions are irrepressibly drawn to sit or lie on newspapers, computer keyboards, folded laundry—whatever is competing for their humans' attention. This wooden tray, painted with a trompe-l'œil design of a scrawny calico kitten sleeping on a precious Lotus Sutra manuscript, one of the canonical texts of Mahayana Buddhism, suggests that this aspect of feline behavior has changed little in 100 years.

Elites and wealthy temples commissioned deluxe sutra copies to appeal for spiritual favor. Practitioners could accumulate merit by chanting the sutras, or paying priests to chant it in their place. Does Shōkun's cat represent a human devotee who has fallen asleep during their observance? Or does it illustrate one of the key messages of the Lotus Sutra, that all sentient beings may attain enlightenment—

some more intuitively than others? In juxtaposing the scruffy kitten with the valuable sutra, the artist seems to consider whether virtue lies more in piety or in compassion, and pokes fun at humans' attachment to material objects.

Ōgaki Shōkun was a lacquer artist and designer from the city of Kanazawa, a center for lacquer production. After training under Takata Mosaburō (1836–1902), he established his own studio in 1892. He received accolades at domestic and international exhibitions for his delicately wrought lacquerware creations; this tray, with its exposed woodgrain, is somewhat unusual in his oevre.

Ōgaki Shōkun, 1865–1937. *Serving Tray with Cat Sleeping on Lotus Sutra, ca. 1920s. Ink, gold pigments, and color on hinoki wood, 11 x 11 x 13⁄16 in (28 x 28 x 3 cm). The John and Mable Ringling Museum of Art, Museum purchase, 2021.*

This glossy box offers a machine-age update on a traditional theme and medium, translating the compact form of a loafing feline into the streamlined idiom of modern design. Lacquer, a natural polymer derived from the sap of the *Toxicodendron vernicifluum* tree, has been used to make objects for daily and ceremonial use since prehistoric times. The deep color of this cat box was achieved by applying multiple layers of clear and cinnabar-tinted lacquer, polishing each as it hardened. The slits of the cat's eyes are accentuated in gold.

Ban'ura Shōgo was born and trained in Ishikawa prefecture, a center for lacquer production. Around 1925, he relocated to Kyoto and established his studio there. An active participant in official state-sponsored art exhibitions, his contributions to the modernization of lacquer were recognized with numerous awards, including an honorary award at the Exposition Internationale des Arts et Techniques dans la Vie Moderne in Paris in 1937, and the Order of the Rising Sun in 1981.

Ban'ura Shōgo, 1901–1982. *Box as a Cat, ca. 1930s. Dry lacquer over cloth, 6¾ x 12 x 7¼ in (17.1 x 30.5 x 18.4 cm). Collection of Robert and Mary Levenson.*

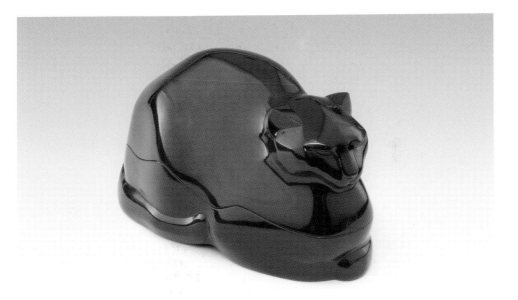

Master Nansen Kills the Cat

Two monks were bickering over a cat. Master Nansen seized the creature, demanding,
"If you can give an answer, I will spare the cat. If not, I will cut it in two." The monks remained
silent, so Nansen killed the cat. That evening, when Jōshū returned, Nansen told him what
had happened. Jōshū took off his sandals, put them on his head, and walked off.
Nansen said, "If you had been there, I could have spared the cat."

This famous *kōan*, recorded by the Chinese Zen monk Wumen Huikai (Jp.: Mumon Ekai, 1183–1260) in his compilation *The Gateless Gate*, has dismayed Buddhists, animal-lovers, and the rational-minded for centuries. Various interpretations of its meaning have been proposed.

Several artists seem to have been untroubled by the story and even found humor in it. The priest and painter Shōkei imagined Nansen theatrically holding his victim aloft, his eyes bulging and biting his lower lip in grim determination. The cat, delicately painted in fine brushstrokes, looks uneasily back at the priest. Sozan Genkyō's Nansen is cool and impassive, cocking an eyebrow at the monks, while the hapless cat dangles by its tail. A woodblock print by Shibata Zeshin depicts Nansen gripping the cat by the scruff of its neck, poised to plunge his sword into its soft flesh. The cat gapes in horror at its gruesome fate.

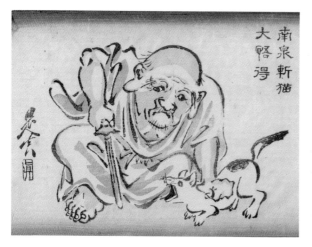

LEFT **Shibata Zeshin, 1807–1891.** *Nansen Kills the Cat and Causes Enlightenment, 1878. Detail from a harimaze sheet by Zeshin, Utagawa Hiroshige III (1842–1894), and Matsukawa Hanzan (1818–1882). Published by Mizuno Keijirō. Woodblock print, ink and color on paper, 14³⁄₁₆ x 9⁷⁄₁₆ in (36 x 24 cm). Image courtesy of Shukado Gallery.*

RIGHT **Shōkei, act. 15th c.** *The Honorable Nansen Kills a Cat, 1495. Hanging scroll, ink and light color on paper, 32⅝ x 15¾ in (83 x 40 cm). Museum Rietberg, Gift of Julius Meuller, © Museum Rietberg, Zürich, photo Rainer Wolfsberger.*

FAR RIGHT **Sozan Genkyō, 1799–1868.** *Priest Nansen, mid-19th century. Hanging scroll, ink and light color on paper, ink on paper, 41¾ x 10¹¹⁄₁₆ in (106 x 27.1 cm). Israel Museum, Gift of the Gitter-Yelen Collection.*

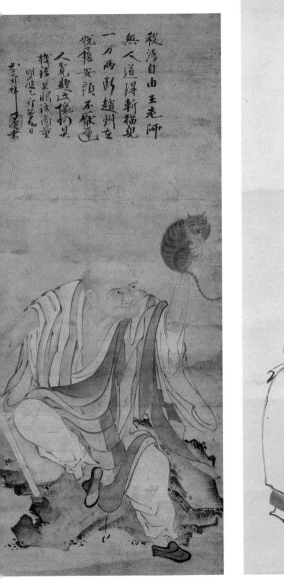

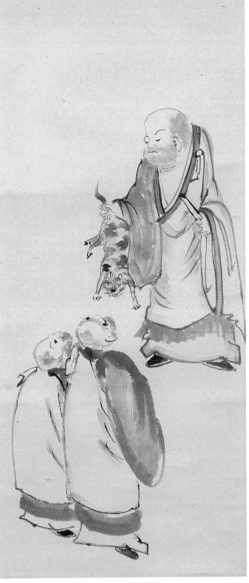

Ōtsu-e Folk Paintings

The relationship between cats and mice has inspired lessons about human folly. In the first of two Ōtsu-e folk paintings, a mouse cheerfully drains a cup of sake, while his companion, a cat, wide eyes fixed upon him, offers a spicy red pepper to make him even thirstier. A sake decanter made from a hollow gourd, the cause of the mouse's inebriation, is placed in the foreground.

The inscriptions reiterate the moral of the painting—to naively forget oneself is to invite calamity. To lighten the lesson, however, the word for "nothing" in the fourth verse is punned with the sound of a cat's miaow, "*nyan.*"

Ōtsu-e is a type of folk painting that dates from the early 17th century. They were made in large numbers and sold cheaply in roadside stalls near the near the village of Ōtsu, the last town on the Tōkaidō and Nakasendō roads through which travelers would pass before arriving in Kyoto from Edo (modern day Tokyo). In other examples of this theme, the roles of the cat and mouse are reversed, such that the mouse plies the cat with alcohol.

Not only deceived, [the mouse]
dances wholeheartedly, and then is caught.

*The reckless mind, thinking **nyan**-thing of*
danger, causes the body to be ensnared.

A wise person said, just as the mouse is
destroyed by the cat, to flatter superiors is
to court disaster.

Unaware that the cat who fills his cup with
sake will take his life,
the mouse drinks, glug glug glug.

Those who do not listen to the sages' teachings will eventually ruin themselves.

RIGHT **Cat and Mouse, first half 18th century.** *Painting mounted as hanging scroll, ink and color on paper, 16⅜ x 11 in (41.6 x 27.8 cm). Minneapolis Institute of Art, Gift of Harriet and Edson Spencer.*

FAR RIGHT **Cat and Mouse, 19th century.** *Painting mounted as framed panel, ink and color on paper, 24 x 9⁷⁄₁₆ in (61 x 24 cm). Private collection.*

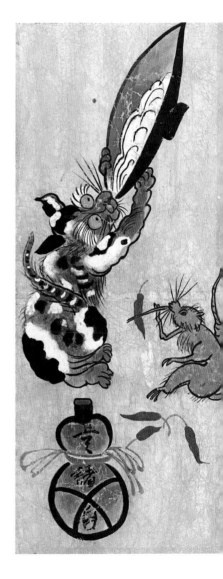

Big Cats

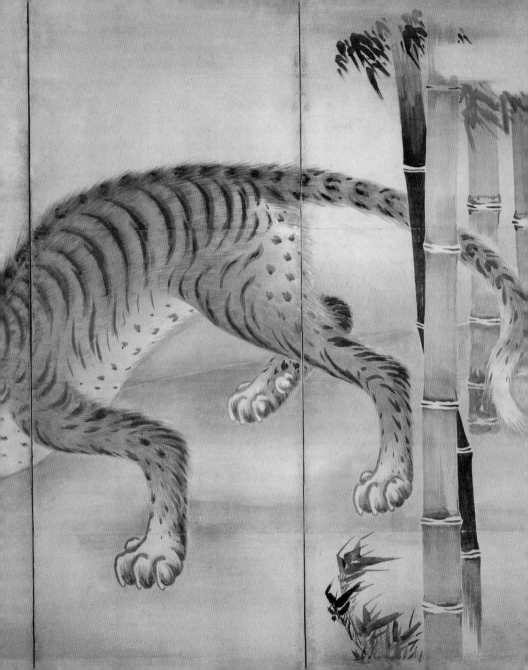

Tiger Symbolism

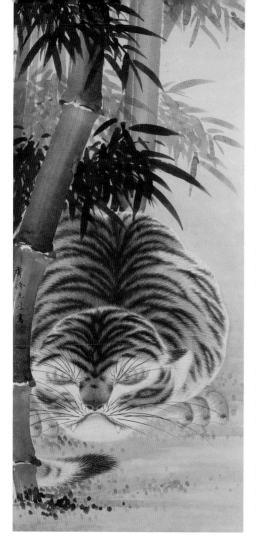

Japan has not been home to big cats like tigers for millenia. Consequently, tigers acquired an ambiguous, semi-mythical status there. Nonetheless, they stride confidently through the visual culture of the archipelago. The animals were occasionally imported during the 18th century for private menageries, but most artists could only imagine how they looked based on hides and paintings brought in from China and Korea, and their smaller cousins. As a result, they are often highly stylized, and sometimes resemble overgrown housecats.

Much of their symbolism in Japan originates in continental Asia, where tigers were once common. Although posing a threat to any human life that strayed into the wilderness, tigers were revered as majestic, even sacred creatures, and represented physical strength, military valor, and righteous leadership. The markings on their foreheads were thought to resemble the Chinese character meaning "king" (王).

In East Asian cosmology, the tiger is the third animal of the East Asian zodiac. Persons born in a tiger year are said to be courageous and energetic, but also short-tempered, attention-seeking, and impulsive.

Watanabe Shusen, 1736–1824. *Sleeping Tiger in Bamboo, late 18th century. Hanging scroll, ink on paper, 49¼ x 22⅛ in/ 125.1 x 56.2 cm (image). Minneapolis Institute of Art, Gift of Harriet and Ed Spencer.*

The White Tiger of the West (Jp.: *Seihō byakko*), along with the Azure Dragon of the East, the Vermilion Bird of the South, and the Black Tortoise of the North, is one of four deities that guard the cosmos from each cardinal direction. As a stellar constellation, the White Tiger encompasses Andromeda, Pisces, Aries, Taurus, and Orion. In Daoist thought, tigers embody yin or female energy, and are the counterpart to the dragon's masculine yang.

For China's bureaucratic class, the image of a tiger silently padding out of a thicket of bamboo conveyed the idea of an upright leader judiciously navigating perils. In Japanese art, the strength and resilience of bamboo, which allowed it to bend without breaking, and the positive attributes assigned to the tiger made this an auspicious and engaging theme. Painted in ink, the contrast between the thick, straight culms of bamboo, the briskly brushed leaves, and the soft pelt of the tiger allowed the artist to display their skill at executing various texture strokes.

Watanabe Shūsen's sleeping tiger is a gently humorous reinterpretation of this theme (page 168). Curled up in a clump of bamboo, a tiger naps peacefully—only under such circumstances, the artist seems to say with a wink, could he get close enough to sketch the king of the beasts. While by no means a realistic depiction of a tiger, Shūsen rendered its markings in fine detail. Lowered ears, tightly closed eyes, and a downturned mouth convey a state of deep slumber. While the tiger dozes, the wind drops; all is still.

Dish with tiger and bamboo, ca. 1720.
Hard-paste porcelain painted with cobalt blue under transparent glaze (Hizen ware; Kakiemon type). Diameter: 5½ in (14 cm). The Metropolitan Museum of Art, The Hans Syz Collection, Gift of Stephan B. Syz and John D. Syz, 1995.

Tigers and Dragons

Clouds follow the dragon; winds follow the tiger.
—Book of Changes

Emerging from churning clouds, a rampant dragon whips the firmament into a frenzy. Below, a grinning tiger steps out of a bamboo grove onto a riverbank, unruffled by the wind and rain. This pairing is described in the *Book of Changes* (*I Ching*), a canonical source for Confucianist and Daoist philosophy compiled during China's Zhou dynasty (1046–256 BCE). According to this text, the combination of tiger and dragon symbolizes the Daoist principle of yin and yang, embodying the complementary counterparts of female and male, earth and heavens, wind and rain. Within the Dao, all things precipitate from the interaction of these two forces.

In Zen Buddhism, the tiger and dragon represent the quiet mind and surging spirit that enlightenment brings. Consequently, images of tigers and dragons are frequently encountered in Zen temples. During Japan's medieval period, monks imported ink paintings of this theme from China, before it took root among local painter-priests like Sesson Shukei. The positive symbolism of tigers also appealed to Sinophilic warrior elites, who commissioned paintings of tigers for temples and as political gifts.

Pair of screens attributed to Soga Nichokuan, active mid-17th century.
Dragon and Tiger, early to mid-1600s. Pair of six-panel folding screens, ink on paper. Each 68¼ x 148½ in (173.4 x 377.2 cm). Cleveland Museum of Art, Leonard C. Hanna, Jr. Fund 1985.

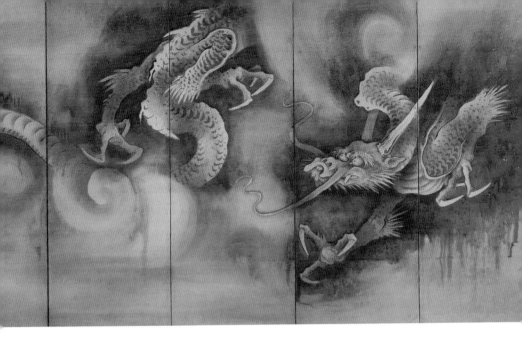

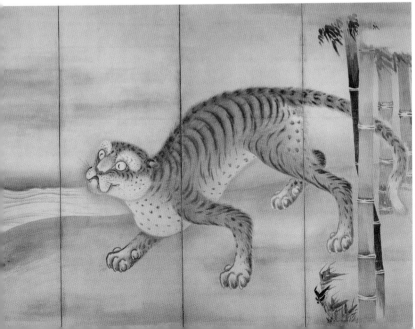

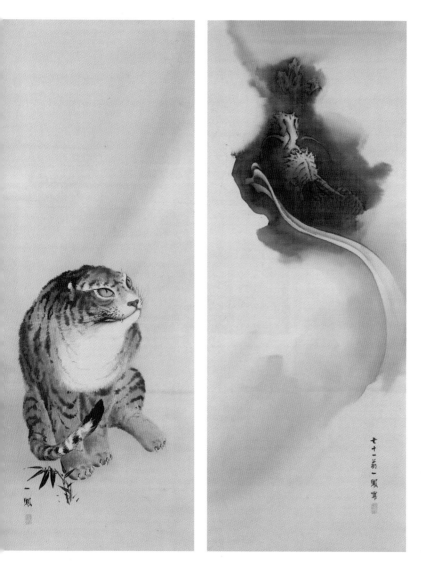

Mori Ippō, 1798– 1871. *Tiger and Dragon, 1868. Pair of hanging scrolls, ink on silk, 40⅜ x 16¾ in/102.55 x 42.55 cm (image, Tiger); 40¾ x 16¾ in/103.51 x 42.55 cm (image, Dragon). Minneapolis Institute of Art, Gift of Harriet and Ed Spencer.*

The Four Sleepers

Pillowed against each other in peaceful slumber are the "four sleepers:" the Zen master Bukan (Ch.: Fenggan) and his pet tiger, the monk Jittoku (Ch.: Shide), and the reclusive poet Kanzan (Ch.: Hanshan). The mysterious and charismatic Bukan, introduced earlier in this book, is said to have turned up at the Guoqing Temple on Mount Tiantai riding on the back of his feline companion—much to the horror of the monks living there. At the temple, he took Jittoku, an orphan, into his care, and performed miraculous healings. His taming of an apex predator can be read

The Four Sleepers, 17th century *Painting mounted as hanging scroll, ink and color on silk, 13⁷⁄₁₆ x 17⁷⁄₈ in/34.13 x 45.4 cm (image). Minneapolis Institute of Art, Gift of the Clark Center for Japanese Art & Culture.*

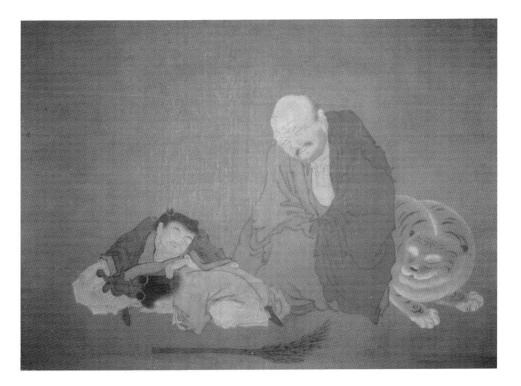

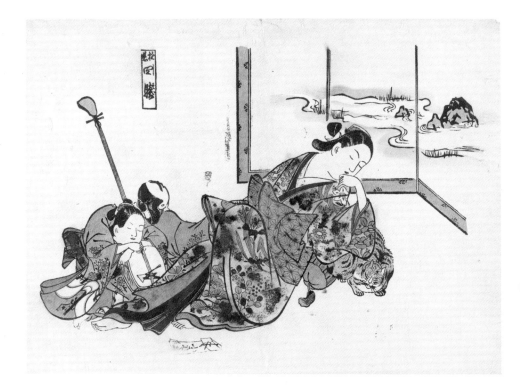

as an expression of his otherworldly abilities. Drawn from Chinese poetry of the Tang dynasty, the theme of the "four sleepers" is said to represent the serenity of the enlightened mind within nature.

The Four Sleepers was one of many classical themes of Japanese art that ukiyo-e artists reinterpreted in the irreverent spirit of their art form. Okumura Masanobu, a founder of the genre, playfully substituted a courtesan for Bukan, her young attendants for Jittoku and Kanzan, and the brothel cat

for a tiger, snoozing companionably. Jittoku's broom, which he is seldom seen without in classical imagery, is replaced with a shamisen. The Buddhist theme is thus transformed into a moment of cosy domesticity within the floating world.

Okumura Masanobu, 1686–1764. *Prostitutes Imitating the Four Sleepers, 1720s. Woodblock print, ink and limited color on paper, with hand-applied color, 10¼ x 15³⁄₁₆ in (26.1 x 38.6 cm). Minneapolis Institute of Art, Gift of Louis W. Hill, Jr.*

Tigers and Warriors

Unlike their mainland counterparts, Japanese heroes had few opportunities to test their mettle by slaying or taming a tiger. Nonetheless, this gladiatorial urge was given full play in theater, fiction, and visual culture of the Edo period. Inspired on events that took place during military campaigns in China and Korea, artists and writers imagined swashbuckling encounters between warriors and tigers. One popular protagonist was Katō Kiyomasa (1562–1611), a senior commander during the Imjin War (1592–1598) between Japan and Joseon Korea.

During lulls in the fighting, Kiyomasa hunted tigers for sport and sent the meat back to Japan in the hope it would restore the vitality of his leader, the general Toyotomi Hideyoshi (1536–1598). A live tiger was also delivered to Hideyoshi's court. According to legend, it lunged at Kiyomasa, who stopped it with a cool stare.

Kawanabe Kyōsai, 1831–1889. *May, the Fifth Month, from the series Of the Twelve Months, 1887. Published by Fukado Komajirō. Woodblock print, ink and color on paper, 14¹¹⁄₁₆ x 30⅜ in (35.7 x 77.1 cm). Image courtesy of Egenolf Gallery.*

Kiyomasa's encounters with tigers were a popular subject of a variety of types of objects. A *tsuba*, or sword guard mounted between the blade and handle of a sword, is decorated with a scene of the warrior stalking a snarling tiger through a pine forest. A humorous interpretation of this legend is depicted on a quilted fireman's jacket (page 179). Here, a playful tiger has made off with Kiyomasa's helmet.

Another famed encounter between a warrior and the king of the beasts is dramatized in Chikamatsu Monzaemon's (1653–1725) puppet play, the *Battles of Coxinga* (pages 177 and 178). Based (loosely) on the exploits of the Chinese miliary leader Zheng Chenggong (1624–1662), Chikamatsu's tragic hero Watōnai is born in Japan to a Chinese merchant father and a Japanese mother (hence his name meaning "between Japan and China"). Watōnai crosses to mainland Asia to liberate China from Manchurian rule and restore the Ming to power. Traveling through a bamboo grove, he meets a fierce tiger fleeing hunters, and subdues it with his bare hands. The tiger then turns against Watōnai's

LEFT **Sword Guard (Tsuba), 18th century.** *Japan, Edo period (1615–1868). Iron, copper-gold alloy (shakudō), silver 3 x 2¾ in (7.6 x 7 cm). The Metropolitan Museum of Art; Funds from various donors, 1946.*

RIGHT **Utagawa Kunisada, 1786–1865.** *Watōnai, from the series Magic Lantern Slides in a Dance of Seven Changes, 1857. Published by Daitokuya Kinjirō. Woodblock print, ink and color on paper, 15⅜ x 10⅝ in (39 x 27 cm). Tsubouchi Memorial Theatre Museum, Waseda University.*

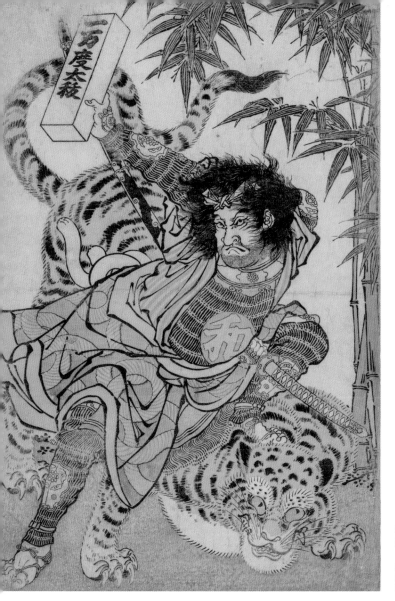

Watōnai and the Tiger in the Bamboo Grove, ca. 1780s.
Woodblock print, ink and color on paper, 15⅛ x 10 in (38.4 x 25.4 cm). Cleveland Museum of Art, Gift of Mr. and Mrs. J. H. Wade.

enemies, destroying their weaponry.

In an exuberant design by Kyōsai (page 175), a folk hero joins forces with an auspicious feline. Brandishing his sword of wisdom, Shōki (Ch.: Zhongkui), a god from the Daoist pantheon known as the "demon queller," scatters a rabble of terrified demons. Carrying him into the fray is a valiant tiger with flattened ears, grasping a red-skinned *oni* in its jaws. Shōki is associated with Boys' Day, now celebrated as Children's Day, which is observed on the fifth day of the fifth month. He is believed to ward off evil, particularly that coming in the form of infectious diseases like smallpox. The mad energy of Shōki and his charging tiger display Kyōsai's exuberant humor, inventiveness, and skill.

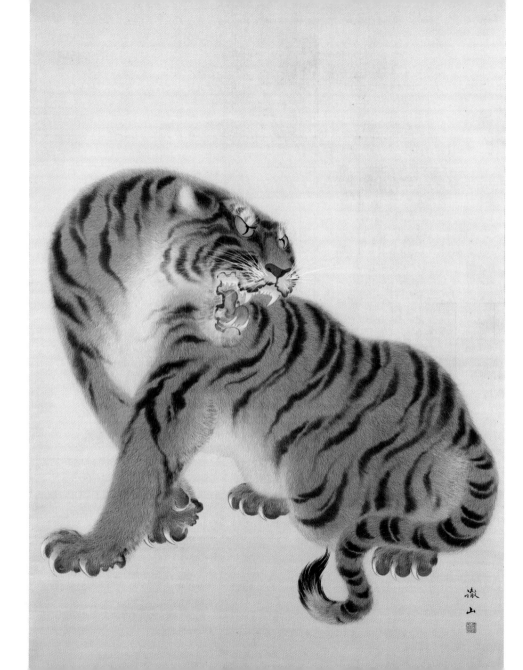

Real Fierce

Painting in the late 18th century, the Kyoto artist Maruyama Ōkyo broke new ground by blending elements of Western-style realism with the abstract values and decorative qualities of East Asian painting. The picture below of a seated tiger, one of Ōkyo's favorite subjects, combines lively naturalism with closely observed detail. Whiskers bristling, it regards the viewer obliquely through green, orb-like eyes. The dense texture and magnificent pattern of its coat is built up by layering blocks of color with thousands of fine brushstrokes to suggest individual follicles. His student, Mori Tetzuzan, whose painting is on the left, pursued even greater levels of formal realism. The ferocious expression, rippling muscular mass, and lustrous coat of his roaring tiger deliver a thrilling spectacle of power and beauty.

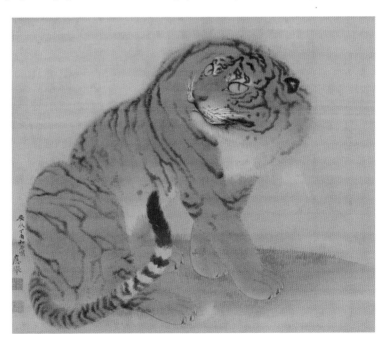

LEFT **Mori Tetsuzan, 1775–1841.** *Tiger, second quarter of 19th century. Painting mounted as hanging scroll, ink and color on silk. 50¹³/₁₆ x 33¼ in/129 x 84.8 cm (image). The John and Mable Ringling Museum of Art, Museum purchase, 2018.*

RIGHT **Maruyama Ōkyo, 1733–1795.** *Sitting Tiger, 1777. Painting mounted as hanging scroll, ink and color on silk, 17¾ x 23³/₁₆ in/45.09 x 58.9 cm (image). Minneapolis Institute of Art, Gift of Harriet and Ed Spencer.*

The Tiger of Ryōgoku

The arrival of a live "tiger" in the seventh month of 1860 in Edo's Ryōgoku district, a locale famous for street performances, expositions, and all things weird and wonderful, was marked by a flurry of prints. Imported by Dutch traders through Yokohama, this exotic creature drew tens of thousands of spectators. The big cat was said to be six months old and seven *shaku* (just over 6½ feet/2 meters) in length. Gauging by the number of gruesome images of it tearing apart live prey, the crowds were particularly delighted by feeding time, when the animal's keepers released chickens into its pen.

Most prints connected with this event, however, depict not a tiger, but a spotted leopard, which at that time was thought to be the female of the species. In Kunimaro's rendering, the animal looks more like a friendly seal than a fierce feline, perhaps belying the claim that it was "drawn from life." The publisher Ebisuya Shōshichi, eager to address this confusion, issued a diptych the following month with images by Kawanabe Kyōsai and text by journalist Kanagaki Robun (1829–1894) to clarify the differences between tigers (*tora*) and leopards (*hyō*) (page 185).

The following year, the Dutch delivered a real tiger to the people of Edo, which was exhibited in the grounds of Fukujuin temple in Kōjimachi. Ebisuya commissioned Kyōsai to depict the animal devouring a dog (page 184). Robun con-

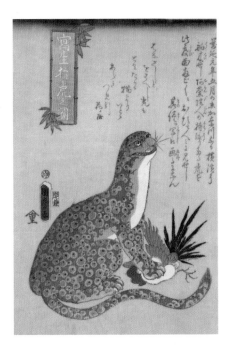

ABOVE **Utagawa Kunimaro (active ca. 1850–1875).** *A Fierce Tiger Drawn from Life, 1860. Published by Jōshūya Jūzō. Woodblock print, ink and color on paper, 14⁹⁄₁₆ x 9⅞ in (37 x 25.1 cm). Rijksmuseum, Schenking van de heer J.P. Filedt Kok, Amsterdam.*

RIGHT **Utagawa Hirokage, active 1860s.** *"The Tiger of Ryōkoku," from the series True Scenes by Hirokage, 1860. Published by Ebisuya Shōshichi. Woodblock print, ink and color on paper, 14¼ x 9¾ in (36.2 x 24.8 cm). The Metropolitan Museum of Art, Bequest of William S. Lieberman.*

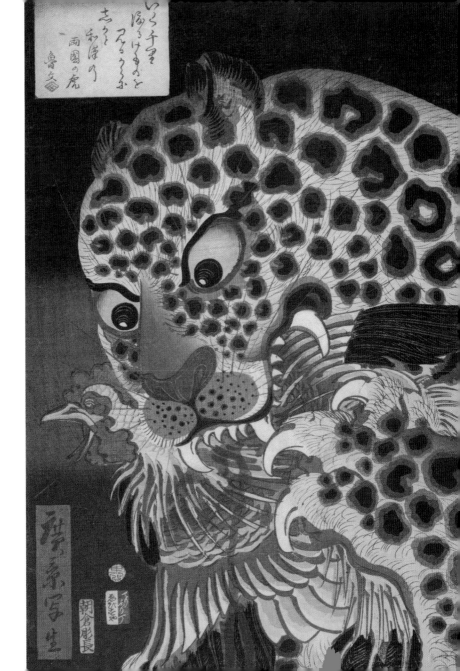

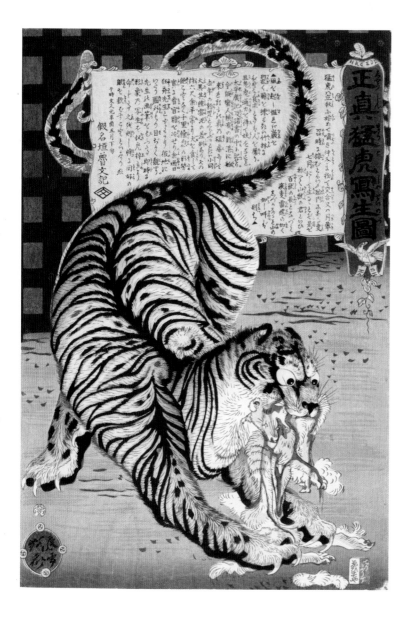

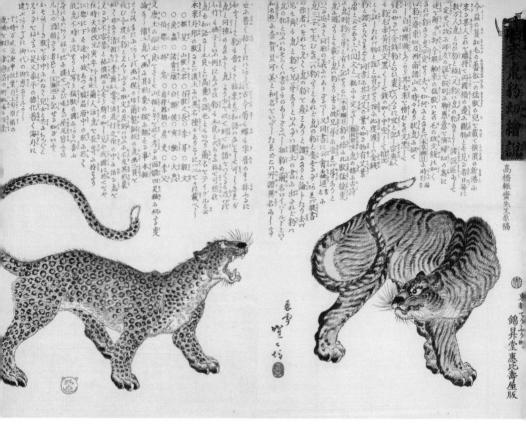

ABOVE **Kawanabe Kyōsai, 1831–1889.**
Illustrated Account of a Tiger and a Leopard from Abroad for Young Readers, 1860. Published by Ebisuya Shōshichi. Diptych of woodblock prints, ink and color on paper. Each sheet 14⅞ x 10¼ in (38 x 26.1 cm). Israel Goldman Collection, London. Photo: Art Research Center, Ritsumeikan University.

LEFT **Kawanabe Kyōsai, 1831–1889.** *Picture of a Real, Fierce Tiger Drawn from Life, 1861. Published by Ebisuya Shōshichi. Woodblock print, ink and color on paper. 14¹⁵⁄₁₆ x 10⅛ in (37.9 x 25.8 cm). Private collection.*

tributed another inscription in florid prose.

> *"When it moves quickly, it is like a storm;*
> *when quiet, it is like a mountain;*
> *when it roars it is like the wind rising;*
> *when enraged it crushes boulders."*

There is, he continued, a world of difference between this "true fierce tiger" and the previous year's leopard.

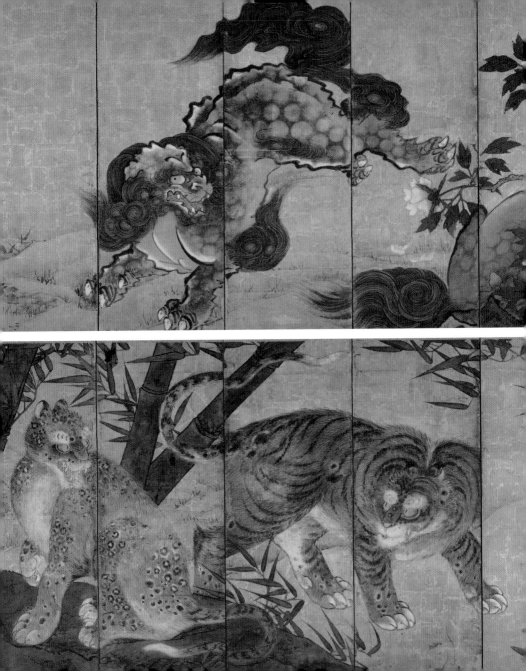

Lions and Tigers

The semi-mythical tiger was occasionally depicted alongside another fabulous beast—the *shishi*, or guardian lion. The *shishi* was absorbed into Buddhist iconography from India and Assyria. In Japan, sculptures of *shishi* were placed at the entrance to Buddhist temples as protective figures and symbols of authority. Monju (Sanskrit: Mañjuśri), the bodhisattva of wisdom, was often depicted riding or sitting comfortably on a *shishi*.

Shishi were employed as decorative motifs in paintings from the Momoyama and Edo periods. The right screen of a 17th century pair is painted with a fantastical scene of dappled lions gambolling in a landscape with blooming peonies. The combination of *shishi* and peonies appears in a famous scene in the Nō play *The Stone Bridge*, in which a *shishi*, performed by an actor with a long-haired wig, dances among peonies. Metallic pigments emphasize the luxuriant curls of the animals' manes and tails, while bulging eyes and toothy grins give them a humorous aspect. More playful kittens than solemn guardians, they project an auspicious, festive mood.

The left screen of the pair, reproduced below, shows a tiger couple—or rather a tiger with a leopard. The leopard was even more unfamiliar to painters in early modern Japan than the tiger, and as mentioned above, were believed to be female tigers. Appropriately, they are shown on the edge of a bamboo grove that bows under a violent wind.

Realistic imagery of lions came via European

Yamaguchi Sekkei, 1644–1732. *Lions and Tigers in Peony and Bamboo, 1668. Pair of six-panel folding screens, ink and color on gilded paper. Cleveland Museum of Art, John L. Severance Fund.*

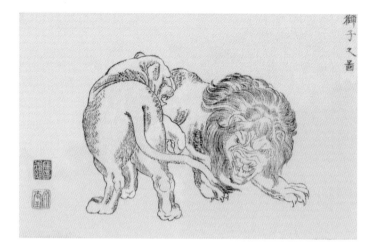

traders and were rapidly reproduced in woodblock print for the curious public. Morishima Chūryō's *A Miscellany on the Red-Hairs* is a compilation of information gleaned from the Dutch stationed in the trading port of Nagasaki and local scholars of Dutch learning, as Western studies was called. The five volumes encompass anatomy, microbiology, zoology, engineering, various other scientific and everyday topics. The illustration of the lion, by painter Kitayama Kangan, is a copy of an engraving in Johannes Jonston's *Historiae naturalis de quadrupedibus libri, cum aeneis figuris* (1657).

Over two hundred years later, the Kyoto painter Takeuchi Seihō was sent to Europe by the Japanese government to attend the Fifth International Exposition for Art and Industry in Paris in 1900. His mission was to "to inspect the situation of the art world in major European cities, and to collect materials for art education." In his six months abroad, Seihō studied

not only Western art, but visited almost every zoo, where he sketched animals from life. At Dresden Zoo, he was able to observe his first lion. On his return, he painted several pictures of big cats, including this pair of hanging scrolls of a lion and tiger. The fresh combination of consummate draftsmanship and expressive brushwork in these paintings startled audiences back home.

TOP **Text by Morishima Chūryō, 1756–1810; illustration by Kitayama Kangan, 1767–1801.** *Picture of Lions, from volume four of A Miscellany on the Red-Hairs (Kōmō zatsuwa), 1787. Published by Shio Yakisuke. Woodblock printed book, ink and color on paper, approx. 8¾ x 6⅜ in (22.3 x 15.7 cm). National Diet Library, Tokyo.*

RIGHT **Takeuchi Seihō, 1864–1942.** *Lion and Tiger, 1901. Meiji period, 1868–1912. Pair of hanging scrolls, ink and color on silk. Each 50½ x 19¹³⁄₁₆ in/128.3 x 50.3 cm (image). Saint Louis Art Museum, The Langenberg Endowment Fund.*

Chapter Nine

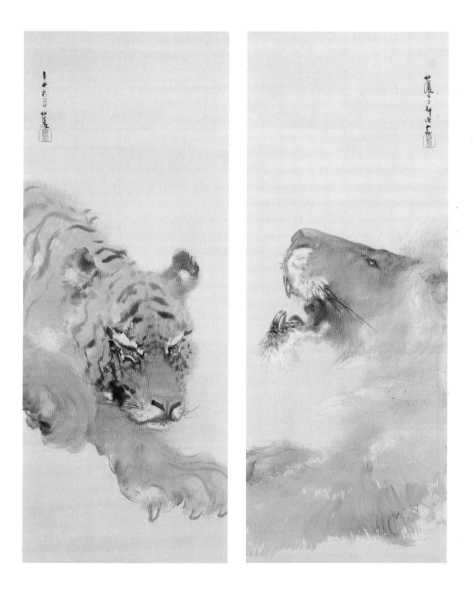

FULL VERSIONS OF CROPPED IMAGES

PAGE 1

PAGE 8

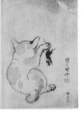

PAGE 13 bottom left

PAGE 27 top

PAGE 36

PAGE 47

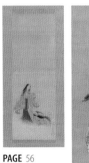

PAGE 56

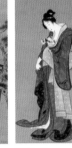

PAGE 59 left

PAGE 63

PAGE 67

PAGE 99

PAGES 122–123

PAGES 132–133

PAGE 144

PAGE 147

PAGE 163

PAGE 179

For my mother, Lyndall Paget, Queen of Cats.

ACKNOWLEDGMENTS

We are grateful to the owners and copyright holders of the images reproduced in this volume for their cooperation. Despite our best efforts, we were unable to contact all copyright holders. We invite unacknowledged copyright holders to contact the publisher for recognition in subsequent printings.

We thank the following institutions and individuals for their support : Fumiko Nakamura, Aichi Prefectural Museum of Art; Taiko Tobari, The Asakura Museum of Sculpture; Art Institute of Chicago; Brigham Young University; Rosina Buckland and Lucia Rinolfi, The British Museum; Andrea Selbig, Chazen Museum of Art; Cleveland Museum of Art; Eisei Bunko; Karin Breuer and Britta Traub, Fine Arts Museums of San Francisco; Jeff Steward, Harvard Art Museums/Arthur M. Sackler Museum; Stephen Salel and Kyle Swartzlender, Honolulu Museum of Art; Israel Museum; Heidi Taylor, The John and Mable Ringling Museum of Art; Library of Congress, Washington D.C.; Los Angeles County Museum of Art; The Metropolitan Museum of Art; Mingei International Museum; Andreas Marks, Minneapolis Institute of Art; Sarah Thompson and Carolyn Cruthirds, Museum of Fine Arts, Boston; Khanh Trinh and Delphine Jakab, Museum Rietberg; National Diet Library, Tokyo; Peter Huestis, National Gallery of Art; National Museum of Ethnology, Leiden; Kōichi Sunaga, Nittaso History Museum; Rijksmuseum; Rhode Island School of Design Museum; Philip Hu and Jason Gray, Saint Louis Art Museum; Jenna Post, Smart Museum of Art, The University of Chicago; Smithsonian Libraries; The Metropolitan Museum of Art; Yurika Saitō, The Silk Weaving Nishiki-e Collection, Nature and Science Museum, Tokyo University of Agriculture and Technology; Tokyo Metropolitan Library; Tokyo National Museum; Tsubouchi Memorial Theatre Museum, Waseda University; Waseda University Library; Chiaki Ajioka; Charles and Robyn Citrin; John Fiorillo; Kurt Gitter; Patricia Graham; Mami Hatayama; Tomo Kosuga, Koga Arts; Noriko Kuwahara; Guillermina Emy LaFever; Robert and Mary Levenson; Hendrick Lühl; Veronica Miller, Egenolf Gallery; Israel Goldman and Koto Sadamura, Israel Goldman Collection, London; Jeffery Cline and William Knospe, Kagedo Japanese Art; Tsuyoshi Morimiya, Morimiya Gallery; Ross Walker, Ohmi Gallery; Phil Marston, Sanders of Oxford; Katherine Martin, Scholten Japanese Art; Akiko Yamada, Shukado Gallery.

Pages 46, 47 and 93 bottom: courtesy of Junpei Sekino; **pages 50, 51:** © Masahisa Fukase Archives, courtesy of Atelier EXB in Paris; **pages 74, 79 bottom:** © Fondation Foujita/ADAGP; **pages 80, 81:** courtesy of The Asakura Museum of Sculpture; **pages 90 bottom, 91 top and bottom, 92:** courtesy of Watanabe Hisako; **pages 32/33, 48 top:** courtesy of Yamaguchi Ayumu; **pages 48 bottom:** courtesy of Kasamatsu Michiko; **page 162:** © Museum Rietberg, Zürich, photo Rainer Wolfsberger

Shutterstock photos—**front endpapers:** Kelly.Lam; **pages 96/97:** MyPixelDiaries

"Books to Span the East and West"

Tuttle Publishing was founded in 1832 in the small New England town of Rutland, Vermont [USA]. Our core values remain as strong today as they were then—to publish best-in-class books which bring people together one page at a time. In 1948, we established a publishing outpost in Japan—and Tuttle is now a leader in publishing English-language books about the arts, languages and cultures of Asia. The world has become a much smaller place today and Asia's economic and cultural influence has grown. Yet the need for meaningful dialogue and information about this diverse region has never been greater. Over the past seven decades, Tuttle has published thousands of books on subjects ranging from martial arts and paper crafts to language learning and literature—and our talented authors, illustrators, designers and photographers have won many prestigious awards. We welcome you to explore the wealth of information available on Asia at **www.tuttlepublishing.com.**

Published by Tuttle Publishing, an imprint of Periplus Editions (HK) Ltd

www.tuttlepublishing.com

Copyright © 2023 Rhiannon Paget

ISBN 978-4-8053-1733-4

Distributed by

North America, Latin America & Europe
Tuttle Publishing
364 Innovation Drive
North Clarendon, VT 05759-9436
U.S.A.
Tel: 1 (802) 773-8930
Fax: 1 (802) 773-6993
info@tuttlepublishing.com
www.tuttlepublishing.com

Japan
Tuttle Publishing
Yaekari Building 3rd Floor
5-4-12 Osaki, Shinagawa-ku
Tokyo 141-0032
Tel: (81) 3 5437-0171
Fax: (81) 3 5437-0755
sales@tuttle.co.jp
www.tuttle.co.jp

Asia Pacific
Berkeley Books Pte. Ltd.
3 Kallang Sector #04-01
Singapore 349278
Tel: (65) 6741-2178
Fax: (65) 6741-2179
inquiries@periplus.com.sg
www.tuttlepublishing.com

25 24 23 10 9 8 7 6 5 4 3 2 1

Printed in Malaysia 2306VP

TUTTLE PUBLISHING® is a registered trademark of Tuttle Publishing, a division of Periplus Editions (HK) Ltd.

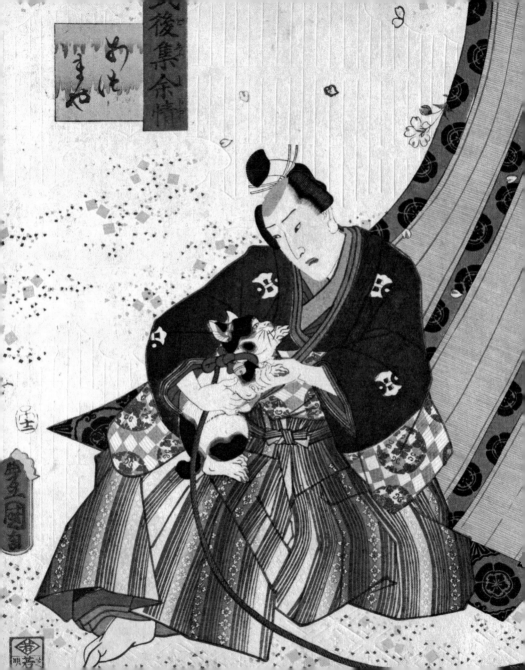